Classic Restaurants

=== OF ===

SUMMIT COUNTY

Classic Restaurants

OF

SUMMIT COUNTY

SHARON MORELAND MYERS

IMAGES COURTESY OF THE
Akron Beacon Journal—Summit Memory Project

THE
History
PRESS

Published by The History Press
Charleston, SC
www.historypress.com

First published 2018

Manufactured in the United States

ISBN 9781467138512

Library of Congress Control Number: 2017955910

Contents

Acknowledgements

Thisbook could not have been written without the gracious assistance of many people. First, Judy James, former Special Collections division manager, and Mary Plazo, current Special Collections division manager, Akron–Summit County Public Library, have both gone above and beyond helping me scan photos from the library's collections for the book. We spent several days scanning photos and items in the archives.

The *Akron Beacon Journal*—Summit Memory Project has been wonderful in allowing the use of many of its images in the book.

Leianne Neff Heppner, president and CEO of the Summit County Historical Society, has also allowed the use of images from the historical society's collection in this book.

The Cuyahoga Falls Historical Society and the Richfield Historical Society also allowed images from their collection to be used.

I would like to thank all the restaurants that submitted digital images of their sites for the book. They are too numerous to list, but their photos are captioned with a courtesy to them.

Thanks to Todd Snyder and Ott Gangl for allowing me to use their images in the book.

And I would like to acknowledge my husband, Al Myers, for his proofreading skills and his support throughout this project.

Preface

Being the daughter of Charles Marcel Moreland, of Marcel's Restaurant, has made this project a labor of love. Meeting the families of the other restaurant owners and seeing how grateful they are that their family's restaurant is being celebrated and remembered has been such a great honor.

This book not only describes the great restaurants but also weaves in the history of the area—mainly the rubber companies' economic effect on the area. Also noted is the colorful and corrupt era during Prohibition, when Akron was one of the first Mafia cities in the twentieth-century Midwest. Illegal booze, prostitution and gambling wove through many establishments.

These restaurants, big or small, plain or fancy, all had special meaning to the community. This is where special occasions were celebrated and memories were made.

During the early 1900s, Akron became the regional hub of Broadway road shows, and rubber became Akron's leading industry. The growing population that fed the rubber industry demanded a host of services, and those included restaurants. Akron's population exploded between 1910 and 1920. Most of the new residents were young men from West Virginia working in the rubber factories, living in boardinghouses and eating out.

As far back as the 1920s, the Akron area was known as a restaurant town. In 1919, Prohibition became the law, causing most of the saloons on Main and Mill Streets to disappear and speakeasies to pop up all over the county. Akron's growth continued. Then the Depression hit just as Akron's tallest

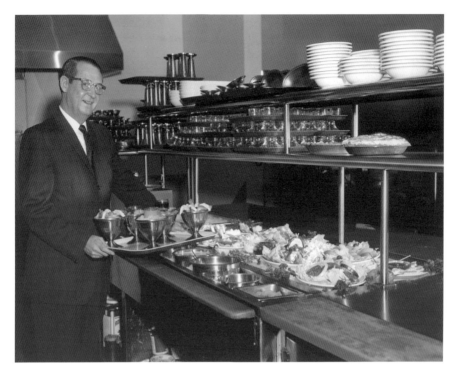

Marcel. *Author's collection.*

bank building opened—the twenty-eight-story Central-Depositors Building, which became the First National Tower. People were soon jumping off the building. Other desperate people turned to gambling. Finally, as the war years came, signs of prosperity returned to Main Street.

Barberton and Norton are known for "Barberton Chicken," which is Serbian fried chicken that began with Serbian immigrants Michael and Smilka Topalsky. The Topalskys were forced to sell their farm during the Great Depression and opened a restaurant in 1933, serving Serbian fried chicken with a rice and tomato sauce seasoned with hot peppers and a side of vinegar-based coleslaw and fries. Serbian fried chicken is fresh, not frozen, and no seasoning is used on the chicken or breading. The chicken is fried in lard, and they cut the chicken differently, using the backs.

Portage Lakes was known for its rowdy bars. During Prohibition, there were many speakeasies at the Lakes. Illegal gambling was in nearly every back room.

During the postwar years, everyone came downtown, as downtown had *everything* that anyone could desire. There were retail stores, movies and

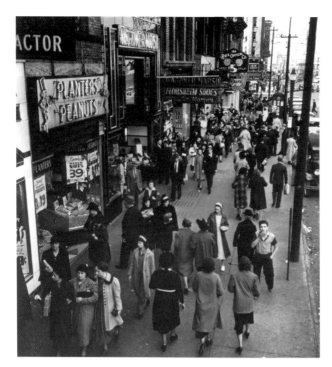

South Main Street.
Courtesy Akron–Summit County Public Library; General Photo Collection.

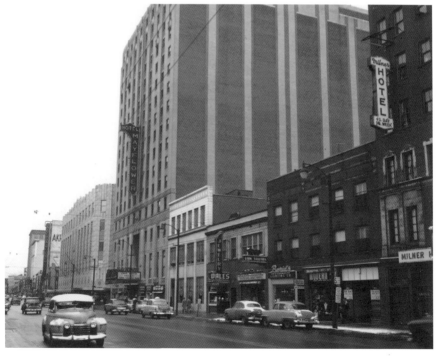

restaurants of all kinds. I've been told that you could get any type of food you could imagine in downtown Akron in the 1950s.

The heyday was in the 1950s and 1960s. The restaurant scene was booming in the 1940s, despite food rationing and labor shortages because of World War II. In 1951, Kenny Nichols, *Akron Beacon Journal* columnist, said that it would be possible to feed thirty thousand people at one time in Akron restaurants. Main Street was choked with cars. Then, in the 1950s, strip shopping centers began taking away some of downtown's customers. Akron's first mall, Summit Mall, opened in 1965. By 1966, nearly half of the stores on Main Street, between Bowery and Mill, were vacant.

State Road between the High Level Bridge and the former State Road Shopping Center was called "Eat Street," as there were forty-one restaurants in that 1.8-mile stretch. I've also heard it called "the Strip." And in Montrose, there is "Restaurant Hill."

The golden age of restaurants continued into the 1960s, but casual restaurants were coming into their own; dozens of fast-food restaurants and drive-in restaurants were opening. We had our share of all of them, like Columbus, Ohio–based Wendy's, McDonald's, Burger King, Arby's and so on. Restaurant food declined in quality as owners embraced the convenience-food trend. And now this trend is changing in the other direction, as many locally owned restaurants celebrate the use of fresh, seasonal ingredients and things made "in house."

North Hill is Akron's melting pot with an Italian history. Once an Italian neighborhood, a more diverse population is filling the gaps left by Italians moving out. There are many eastern European and Asian immigrants moving in.

In the 1970s, the Merriman Valley wasn't much more than a cow pasture, being former swampland adjacent to the Cuyahoga River. During the 1980s, an array of retail stores and restaurants popped up, with Crocker's and the Wine Merchant being two of the first. The Valley was accessible to North Hill, Cuyahoga Falls, West Akron, Bath and Medina, so it was a great place for upscale restaurants.

With Akron's downtown declining, housing and retail, along with restaurants, popped up in the Valley. In the 1980s, the Valley was a yuppie mecca. It has been unusually difficult to stay in business in the Valley. Traffic congestion is part of the problem, as is the fact that the Valley had a real image problem: a stigma of snobbery.

Liberty Commons was opened around 1976 by Anthony Petraca. Originally, it was to be specialty shops, like Quaker Square, but that didn't

work. Liberty Commons is not visible from Merriman Road, so people drive by instead of stopping.

Clubs became the *in* thing for singles in the 1980s. The 1980s mentality for food became "big is better and better is more." Large servings of ordinary food became the norm.

Chefs became prominent stars in a restaurant's success, beginning in the 1980s. Every time a chef moves from one restaurant to another, the losing restaurant closes or suffers until another popular chef takes over. The consistency of the quality of food isn't maintained like it was during the golden age of restaurants. If the chef is off, you know it. Chefs are still the big draw.

Downtown Akron and the University of Akron are blending together, along with locally owned upscale restaurants and hip loft condos.

With Akron's ancestry being very much German, it is no surprise that in 1996, Akronites named sauerkraut balls their official food!

So, let's walk down memory lane.

Downtown Akron Restaurants

THE AMERICAN HOUSE

The American House was located on North Howard Street close to West Market Street. Florence Weber established the inn after coming to America from Germany in 1832 and Akron in 1835, when he clerked at stores at Canal Locks 4 and 16. The Ohio and Erie Canal was constructed in the 1820s and 1830s. The canal connected Summit County with the Cuyahoga River

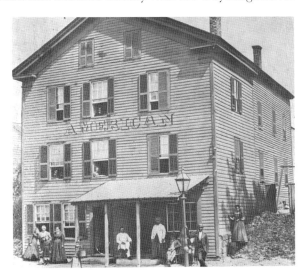

American House. *Courtesy Akron–Summit County Public Library; Summit County Historical Society Collection.*

and, later, with the Ohio River, and the canal runs right through the middle of downtown Akron. Florence Weber married Margaret Steinbacher, sister of Edward, one of Akron's first druggists. Weber housed many immigrants who came here looking for homes.

BARBEQUE-MATIC

The Barbeque-Matic Restaurant was opened in 1943 at 52 East Market Street by owner-chefs Kimon and George Papageorge. The brothers previously owned the Splendid Restaurant at 42 East Mill Street.

In 1946, an associate, Valerio "Bruno" Brunamonti, invented the barbeque-matic machine, which barbecues meats and fowl with charcoal fire. This was the only charcoal barbecue house in Akron. It had an open-view rotisserie so that passersby could see the cuts of meat in the process of being barbecued. The vent was positioned so that the aroma wafted out into the street. The Papageorges had their own secret seasoning too. They were famous for their rosemary and garlic chicken. They closed in 1964.

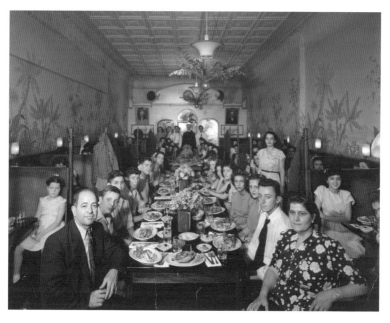

Barbeque-Matic crowd, 1946. *Courtesy Papageorge family.*

BLACK WHALE INN

The Black Whale Inn opened in 1911 at 125 South Main Street, adjoining the Strand Theater. Artist Shrader of Cleveland, who designed the décor for the Astor in New York City, designed the interior of the Black Whale Inn. It was a Venetian garden theme, with colored lights hanging from the ceiling. The restaurant sat one hundred, and the men's dining room sat sixty. In 1914, William Davenport, proprietor, was found not guilty on charges of violating the ordinance prohibiting music in saloons. In 1917, the site offered a free lunch if you bought a nickel beer. In 1919, the sign broke loose and fell on a man while the sign was being lowered to the street. The Black Whale Inn was known as one of Akron's most outstanding restaurants until it closed in 1918 due to Prohibition.

CENTRAL PARADISE CAFÉ

The Central Paradise Café, at 124 West Bowery Street, across from the YMCA, was owned by John Bouras since 1928. Charles and Nick Anthe operated it from 1950 until 1958, when Gust Moise became the operator and renamed it Moise's in 1960. Moise did a large amount of remodeling with a turquoise, tangerine and white décor, along with French paneling of gold iodized aluminum. Moise was the chef at Westgate Lounge before this. It became Bahama Buck's Restaurant and Lounge in the 1970s and 1980s.

CLARK'S RESTAURANT

Clark's Restaurant was opened in 1926 by founder J.B.I. Clark, who had his first restaurant in 1896 in Cleveland; Clark's Restaurants became a chain. Clark sold his interest in 1922 to Waldorf Systems in Boston but bought it back in 1929. The restaurant began in what was the Waldorf Restaurant in the Howe Hotel at 9 South Main Street. In 1929, A. Yates Clark announced that the restaurant would be called Clark's. It was remodeled in 1932. The dining area was called the Apple Room and could seat 72 people, while the front counter could seat another 36. In 1929, it could feed 2,200 people per day. It never closed and served more people between 1:00 a.m. and 5:00

a.m. than during evening hours, as people would drop in for a cup of coffee on their way home from work. In 1943, it had to close at midnight because of the war.

In the 1930s, the restaurant became a Jazz Age favorite, with police officers and gangsters frequenting the place. Being open all night and being close to the Palace Theater, actors would come in after stage shows. In the 1940s, servicemen and war-effort workers were the clientele.

In 1948, the restaurant was running out of space, so it moved to the Delaware Building to a two-hundred-seat restaurant at 143 South Main. The new site had a colonial style, with a wood and marble front. The restaurant was said to have been very clean. This was the same year that manager Everett West bought the old Clark's in the Howe Hotel and changed the name to Twenty-Four Hour Restaurant.

In 1963, former busboy Morris D. Miller was made president of the firm as Yates retired. In 1964, Clark's staff of thirty-nine went on strike because

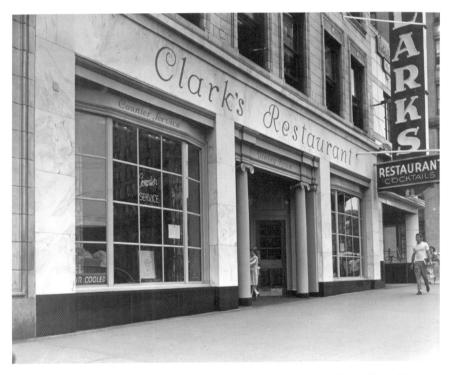

Clark's Restaurant exterior, 1949. *Courtesy Akron–Summit County Public Library; Akron Beacon Journal Photo Collection, Summit Memory Project.*

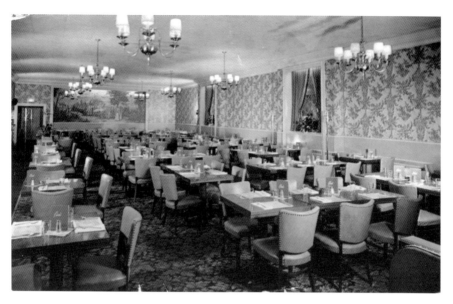

Clark's Restaurant. *Courtesy Akron–Summit County Public Library; Ruth Wright Clinefelter Postcard Collection.*

a supervisor threatened to lay off a veteran worker. The union got involved, and the restaurant locked its doors and didn't reopen. One week after the strike, the owners decided to sell the business at 143 South Main.

THE COLONIAL RESTAURANT

The Colonial Restaurant was located at 312 South Main Street and was owned by Chester Igert and Hilton Jones. They opened the restaurant in 1935. The restaurant had a balcony room. Igert and Jones previously owned Harmony Lane Restaurant in the Milner Hotel at 281 South Main Street. In 1947, Jane and Doug Brown bought the Colonial from Igert and Jones. The Browns previously owned the Oxford Restaurant at 274 South Main Street. The Oxford was known for its creamed chicken soup. The Colonial closed in 1975 due to inflation.

CRAVE

Crave opened in 2005 at 57 East Market Street on the same block as Three Point. The owner was Aaron Hervey, and DeAnna Akers was the chef. Crave has a diverse menu with global influence in a contemporary, art-filled setting. Crave is located in a building called Castle Hall, which was refurbished in 2004.

The building was built in 1871 by Martin Crumrine, who was a stonemason and owner of Akron Granite and Marble Works on North High Street. The building was originally called the Crumrine Block and was a Queen Anne–style building. Crumrine was active in fraternal organizations, and the Knights of Pythian had space in the building from the time that it was built until at least 1979. The three-story building was once home to Akron's first law school. In 1900, there was a bowling alley in the building. A fire a few doors down in 1894 nearly blew out all the windows. In 2007, Crave celebrated the comeback of the grilled cheese and tomato soup. It had removed it from the menu, but the patrons wanted it back!

THE CRYSTAL RESTAURANT

On May 16, 1916, the building containing the Crystal Restaurant collapsed, leaving nine dead, thirty badly injured and many slightly injured. The restaurant was located on South Main Street and Quarry (now Bowery). With a loud roar at 6:05 p.m., the one-story structure caved in just as the place was filled with evening diners. It was a narrow building that housed the *Beacon Journal* from 1898 to 1911. It became the Crystal Restaurant in 1913.

Owner Gust Serris complained to the construction crew that was blasting rock to build the Delaware Building next door to the restaurant that his dishes and customers were being rattled by the explosions. He was ignored. Two more explosions shook the building, and it fell onto the patrons and servers. This blast was just five feet from the restaurant wall. Two weeks before, a blast had caused the Strand Theater wall to spring about three inches. The collapse could be heard for blocks.

The building had been condemned four years prior to the collapse. The building was poorly constructed, and a strata of sand existed between the foundation and solid rock. However, state inspectors determined that Franklin Brothers Contractors had planted dynamite too close to the

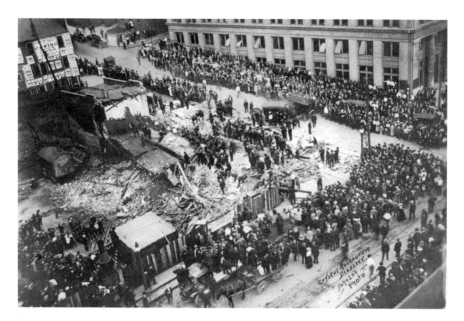

Crystal Restaurant. *Courtesy Akron–Summit County Public Library; Ruth Wright Clinefelter Postcard Collection.*

restaurant, undermining the foundation. Franklin Brothers faced forty-two lawsuits from victims' families. By 1917, the company had settled every case, paying a total of $75,000.

A new Crystal Restaurant was opened on North Howard Street in late 1916, where it continued until the mid-1920s. The restaurant eventually returned to Main Street with a number of different owners and closed in the 1970s. One owner was Charles Marvin, "Mr. Juke Box," who owned the Crystal from 1951 until 1969, when he sold it to Alex Marinkas. Marvin was a partner in the Diamond Grille in the early 1940s with Nick Thomas. Marvin bought Bell Music in 1956 from Ed George (Tangier), along with nine other jukebox operations, and created the biggest coin machine firm in Ohio.

DIAMOND DELI

The Diamond Deli, at 378 South Main, has been around as one version of the name or another for about forty years. There were only two owners

before the current owner: Chuck Magilavy and his sister, Lynda Slikkerveer. They purchased the deli in 1997. Pat Calet was the founder and was famous for her carrot cake. Calet sold the deli to Connie Krim in 1994. Krim had to sell the deli because she had two small children at home.

Pat's Diamond Carrot Cake

4 eggs beaten
2 cups sugar
1 ½ cups vegetable oil
2 cups flour
2 teaspoons baking soda
3 teaspoons cinnamon
1 teaspoon salt
3 cups grated carrots
½ cup chopped nuts
1 (8-ounce) can crushed pineapple, drained

Mix eggs, sugar and oil. In a separate bowl, sift together flour, baking soda, cinnamon and salt. Add to egg mixture. Add carrots, nuts and drained pineapple. Bake in 9- by 13-inch pan at 375 degrees for one hour. Cool and then frost. Makes 24 servings.

Icing

1 stick margarine
16 ounces cream cheese
2 teaspoons vanilla
1 pound box of powdered sugar

Blend butter and cream cheese until smooth. (If doing this by hand, you might want to let the margarine soften first.) Blend in vanilla and powdered sugar.

Charlene Nevada, *Akron Beacon Journal*, February 12, 1995, page 141

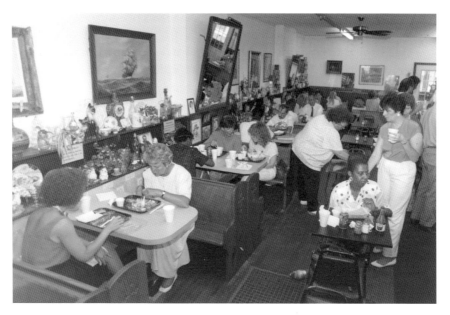

Diamond Deli lunch crowd in downtown Akron, 1992. *Courtesy Akron–Summit County Public Library;* Akron Beacon Journal *Photo Collection, Summit Memory Project.*

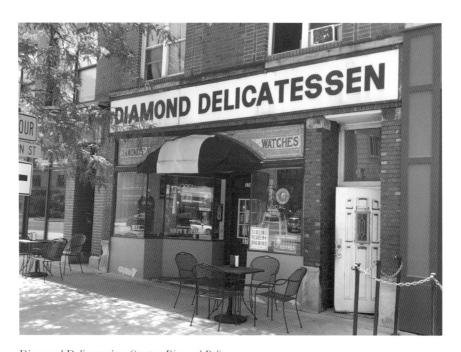

Diamond Deli exterior. *Courtesy Diamond Deli.*

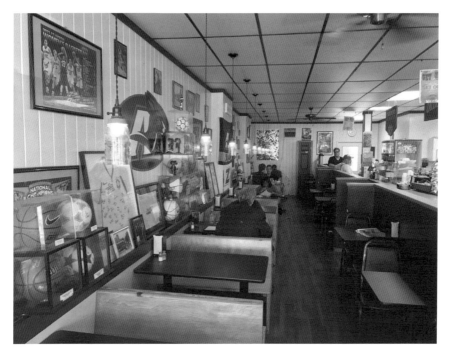

Diamond Deli interior. *Courtesy Diamond Deli.*

The Diamond Deli has a signature salad, grilled cheese and wraps. It is known for its chalkboard menu, with sandwiches named after family members. Staff are a close-knit family. In 2017, the owners opened a kitchen inside R. Shea Brewing, serving sandwiches and, what else, carrot cake! Ron Shea is the owner of R. Shea Brewing at 1662 Merriman Road. The brewery opened in 2015, with its first beer being Rubber City Red. It has a 3.5-barrel system and a 1-barrel system for smaller batches.

DIAMOND GRILLE STEAKHOUSE

Jennie and Nick Thomas purchased the building that became the Diamond Grille at 77 West Market Street in 1941. Charles Marvin was a partner in the early 1940s. There are three dining rooms with a rustic décor. Its men's club atmosphere attracts celebrities. It is famous for its steaks. Brothers Ted and Nick Thomas ran the business after the passing of their parents. It's a hangout for all the big names from the Canton Pro Football Hall of

Joseph Sr. also operated the Hub Café at 40 East Mill Street from 1948 until his death in 1964. In 1933, he opened a café with the same name on South Howard Street. In 1946, he moved to another location on South Howard before moving back to the 40 East Mill Street location. Joseph Sr.'s son, Joseph W., operated the Hub Café until 1983. In 1982, Joseph W. filed to reorganize under U.S. bankruptcy laws. Joseph Jr. changed the name to Joe Gareri's Restaurant. Changes were also made to the décor and the menu. The site was known for its Italian cuisine. Joseph Sr.'s daughter, Pam, made all the pastries for the restaurant.

In 1979, an electrical wire shorted out in the kitchen, causing $12,000 worth of heat and smoke damage throughout.

GEORGIAN ROOM

The Georgian Room was located on the second floor of the O'Neil's Department Store on Main Street. The Georgian Room projected a feeling of 1930s style and elegance. It was a 225-seat restaurant with chandeliers, linen tablecloths and flowers. There was heavy crown molding and wainscoting

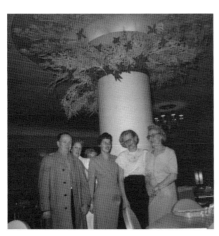

Georgian Room, O'Neil's Department Store at Christmas. *Courtesy Akron–Summit County Public Library; General Photo Collection.*

painted Wedgwood blue. The wallpaper was a blue and apricot flowered print. There was a salad bar around a large pillar in the center of the room.

The menu was small by today's standards—just ten entrees, seven salads and eighteen sandwiches along with appetizers and desserts. The Banana Boat was a healthy salad of fruit and cottage cheese. There was a fashion show every Friday at noon. The Georgian Room catered to children with a chicken casserole served in a ceramic red hen, and milk came in a ceramic cow.

GUS GIRVES BROWN DERBY

The son of a Greek immigrant, Gus Girves founded the Brown Derby chain in Ohio. The first Brown Derby was located at 1157 East Market Street in 1941 across from the Goodyear tire plant. Girves opened the second restaurant in 1957 in Highland Square, and several more followed. There are currently five locations in Ohio. The son and grandson of Gus Girves run the restaurants now.

The Highland Square location sat 125 and was decorated by Chez Del Interiors with a blend of black, gold, white and rust. A wall in the cocktail lounge was metallic gold. There was a mural of Balinese horses behind the bar and a large T-Ang Dynasty horse of stone that sat amid plants in a planter at the entrance. There were beaded-glass encased candles at every table.

The first Brown Derby on East Market was popular with the laborers at the Goodyear tire plant. There were three shifts at Goodyear, and people would stop for a steak and a beer or whiskey after work. One year, the restaurant had the Budweiser Clydesdale horses in front of the restaurant on East Market.

The Brown Derby was the originator of the salad bar.

Brown Derby Highland Square exterior, 1980. *Courtesy Akron–Summit County Public Library; Akron Beacon Journal Photo Collection, Summit Memory Project.*

HAMBURGER STATION

Jim Lowe founded the Hamburger Station in 1975 at 105 South Main Street. He worked at Thacker's for more than thirty-five years before opening the Hamburger Station. Lowe served in the army during World War II and returned to Thacker's after the war before starting out on his own in 1975. He chose a western theme for the décor. It had a rustic look with old barn beams, rough-hewn bar stools and plank flooring. Some stools had real saddles and stirrups instead of seats.

Fresh-cut fries with malted vinegar and burgers served with only pickles and onions were the specialty. Lowe opened the second restaurant at 3275 State Road in Cuyahoga Falls in 1976. The new place had a fenced area with real ponies.

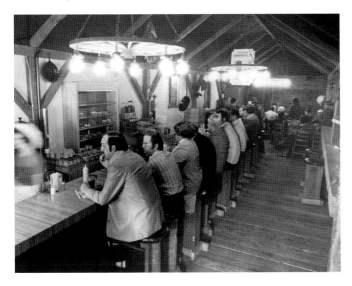

Hamburger Station, 1975. *Courtesy Akron– Summit County Public Library;* Akron Beacon Journal *Photo Collection, Summit Memory Project.*

HATTIE'S CAFÉ

The first Hattie's Café, opened in 2006 by the Hattie Larlham Organization, was located at 164 North Main Street in Hudson. This location closed in 2013. The Hattie Larlham Organization is a nonprofit, work-training program for adults with disabilities. This program teaches people about food service so that they can have a career in hospitality.

The second location opened in 2008 on Brown Street, near the University of Akron, and closed in 2010. The owners opened a café in the Main

Akron/Summit County Library in 2008, and it closed around 2015. The only location that is still open is at 520 South Main Street at Canal Place. This location opened in 2015. There is also an online store.

IACOMINI'S/LI'L JOE'S/PAPA JOE'S

Eletta and August Iacomini began serving spaghetti in a room in their home on West Exchange Street in 1932. And that was the beginning of Iacomini's Restaurant, where son Joe Iacomini and his brothers worked. The restaurant was rebuilt after a fire in 1953. It was known as a place for family gatherings and celebrations. There was a glassed-in kitchen so patrons could watch the chefs at work. One dining room had clouds, rain and sunshine projected on a wall. There was also a lobster tank. Pompeii shrimp was a specialty.

Pompeii Shrimp

1 pound raw medium shrimp in their shells
½ pound (2 sticks) butter
¾ cup finely chopped onions
1 cup flour, plus flour for dusting
⅓ teaspoon dry mustard
2 tablespoons lemon juice
2 tablespoons chicken soup base (see note)
2 eggs beaten with 2 tablespoons milk
dry bread crumbs
oil for deep frying

Place shrimp in a saucepan with 2 cups cold water. Bring to a boil and simmer just until shrimp are done, about 2 minutes. Drain shrimp, reserving liquid. Peel shrimp; cut into small pieces.

In a sauté pan, melt butter. Sauté onions until they are tender. Add the 1 cup flour and whisk over medium heat for 1 minute. Measure out 1¼ cups of the shrimp cooking liquid. Add to pan, whisking until smooth and thick. Whisk in dry mustard, lemon juice and soup base. Stir in shrimp. Refrigerate until cool.

Form mixture into balls the size of walnuts or smaller. Roll in flour; shake off excess. Dip into egg, and then roll in bread crumbs. Fry in a deep fryer until golden and warmed through. Drain on paper towels. Serve immediately.

Mixture also may be used as a stuffing for mushroom caps.

For a gratin appetizer, make shrimp mixture but do not refrigerate. Spoon into ovenproof cups or clean clam shells. Sprinkle with bread crumbs. Bake at 350 degrees for about 15 minutes, or until crumbs are golden brown and shrimp mixture is bubbly.

Note: Chicken soup base is a concentrated chicken broth paste available in many stores, including West Point Market.

Jane Snow, *Akron Beacon Journal*, January 9, 2002, page B2

In 1969, Li'l Joe's Pub was opened in the former Poor Richard's Pub at 1911 Cleveland-Massillon Road. Poor Richard's had been owned by Marilyn and Richard Aberth since 1965. This location was a rustic, Adirondack-style lodge with a wide menu selections and large portions. The interior was red and black with a free-standing fireplace in the main dining room along with paneled walls and wood beams. Joe's son, Gene Iacomini, managed this location until 2000, when Ken Stewart purchased it.

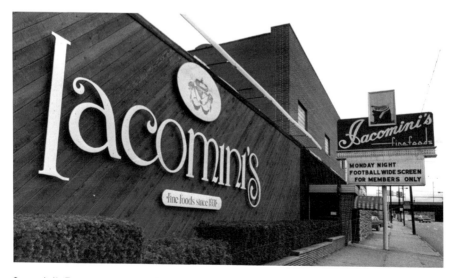

Iacomini's Restaurant, 1981. *Courtesy Akron–Summit County Public Library; Akron Beacon Journal Photo Collection, Summit Memory Project.*

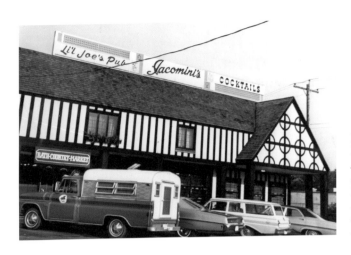

Li'l Joe's Pub, Bath, 1969. *Courtesy Akron–Summit County Public Library;* Akron Beacon Journal *Photo Collection, Summit Memory Project.*

In 1973, Joe Iacomini opened Li'l Joe's Pub at 5416 Darrow Road in Hudson, with Curt Blondheim as chef. Joe and Gene Iacomini and Judy Amato, Joe's daughter, managed this location. Plants hung from the beamed, vaulted ceiling. There was a lengthy menu, with lobster and prime rib stealing the show. The restaurant was sold in 1985 to Ed Barr, who opened The Pub.

In 1984, the sole owner of the West Exchange Street restaurant, Norma Iacomini, filed for bankruptcy, citing one-way traffic on West Exchange, declining population in Akron and the demise of the rubber plants as reasons for filing. In 1986, the restaurant closed, and all restaurant items were auctioned off.

In 1986, Joe Iacomini was ready to get back into the restaurant business after retiring a few years earlier, and he bought the former Lodge Restaurant at 1561 Akron-Peninsula Road with his daughter, Judy Amato, and named it Papa Joe's. The Lodge was formerly the Willow Inn in 1950 and was owned by Daniel Petkanich. In 1952, it was owned by Dan and Judy Peck and was called Peck's Indian Lodge. The restaurant has expanded over the years and seats more than three hundred in eight rooms. Judy's son and daughter are part owners in the restaurant. In 2014, they installed two charging stations for Tesla electric cars. They make Li'l Joe's famous lobster bisque every Friday with fresh chunks of lobster.

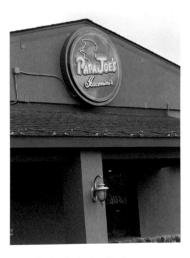

Papa Joe's. *Author's collection.*

JACK HORNER'S

Jack Horner's was opened in 1942 at 395 East Market Street by Frank Wren. It was named after the nursery rhyme "Little Jack Horner." William P. Owen purchased the restaurant in 1946 when Wren's health was failing. It soon became a regular haunt for downtown business people, college students and coffee drinkers. The restaurant was originally a twenty-nine-seater. It was torn down to make way for a new seventy-five-seat restaurant in 1960. Three more additions followed until 1984, when it seated four hundred. Son William J. Owen operated the restaurant until 1996, when it was sold to Suma Hospital.

Plum pie, potato-cheese omelets with cheese sauce and Sir Beef (a roast sirloin sandwich) were popular items. Jack Horner's offered home-cooked meals at good prices with good service. It was open seven days a week from 6:00 a.m. until 1:00 a.m. After 1996, the owners moved to Fairlawn for three years but had to close because the high rent made it impossible to make a profit.

JACOB GOOD/BIG CITY CHOP HOUSE/THREE POINT

Tracy Roadamel opened Jacob Good at 43 East Market Street in an 1871 historic building with a $1 million décor budget in 2003. Roadamel had previously managed Peter Shears in Canton. The interior was mauve, taupe, wine and gold. There was a black granite bar. It retained the high ceilings. The five-thousand-square-foot space sat 150 in the dining room and 20 at the bar. The food was upscale and contemporary with Asian accents. Chef David Ash replaced Chef Michael Meffe in 2004. The restaurant closed in 2006, with Roadamel citing "personal problems."

The restaurant was named after Jacob Good, who had a grocery store in the building in the 1800s. Big City Chop House moved into the space in 2006.

Michael Aberini, Tom Mitchell and John Kouvas were the owners of Big City Chop House. It was an old-school Italian restaurant and steakhouse. It was upscale casual. They installed new cherry hardwood floors before opening. In 2010, owner John Kouvas sold the restaurant to Chad Leek and Dominic Fragomeni, who changed the name to Three Point and opened with a new menu, specializing in meat, seafood and pasta.

In 2014, Blu Jazz Club opened below Three Point. The upscale club sat 150 and had a gallery of fifty album covers and thirty photos of jazz greats. In January 2017, Three Point closed.

JOE'S DINER

Joe Robichaud bought the then-closed O'Mahoney Diner at 71 West Center Street in 1929. By 1955, he needed more space and bought a larger one from Salem, Ohio. In 1980, the diner was operated by Paul Davis, and the sign was changed to just "The Diner." In the mid-1980s, the City of Akron purchased the diner and the property it was on, as the site was in front of Canal Square. The diner was then sold for $1 to the Summit County Historical Society and moved to the former B.F. Goodrich building at South Main and Cedar. In 1991, there was talk of restoring the diner to the tune of $300,000. I hear it is now part of the cafeteria building at the Illinois Railway Museum.

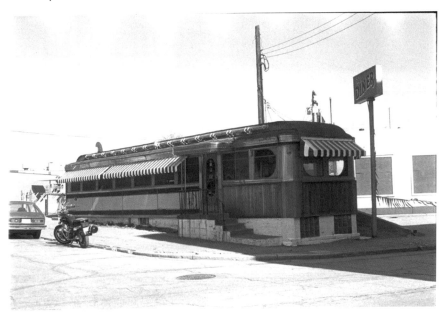

Joe's Diner at 41 West Center Street. *Courtesy Todd Snyder.*

KAASE'S

Kaase's Restaurant was at 53 East Mill Street and was opened in 1915 by Carl Kaase, who was a baker. He put some tables in his bakery and served food and baked goods. He opened the second floor as a tearoom with ten tables and dining. He died of heart disease in 1923 at the age of thirty-five, just after moving into their country home across from Fairlawn County Club. His wife, Marguerite, expanded the business after his death. The restaurant moved to 47 East Mill in the Masino Building. In 1926, she leased a room adjoining Acme no. 75 on Dopler Street that was opened as a pastry shop, establishing the Kaase/Acme business relationship.

The original bakery became a restaurant that she sold in 1925 to Thomas Sweet, who continued to expand the restaurant. It served steak, duckling and chicken. The building was owned by Anthony Masino Sr., who was a musician and candymaker. Masino sold the building to Kaase. Mrs. Kaase wanted a tearoom and persuaded sisters Louise and Fanny Masino to operate it. Fanny and Louis were co-owners of Kaase's restaurant for forty years.

The restaurant was redecorated with a Russian theme, a Bohemian atmosphere and artistic detail everywhere. Artists painted the walls to depict Russian scenes taken from Balieff dancers of the Chauvre Souris. Each panel shows dancers in different poses in peasant costumes. The color scheme was mauve and magenta, with silver leaf on the panels and ceiling and a gray rug with blocks showing modernistic designs. The draperies were Celanese satin, taffeta and gauze in magenta. Louise Masino was the manager of the dining room for many years. During this Bohemian era, she imported clever Russian costumes for all the waitresses. After the death of Louise and Fanny, their nephew, Charles Masino, took over.

In 1957, Sweet retired and sold Kaase's to George Aberth and some key Kaase's employees. Kaase's closed in 1966.

The sticky rolls and Creamed Chicken in Fried Potato Baskets were two popular items on the menu, which also included dainty salads, fruit and gelatin salads and club sandwiches. People would stand in line for the Creamed Chicken.

Mrs. Kaase married a Hungarian violinist, Duci de Kerekjarto, in 1926 and operated a tearoom in Cleveland. In 1930, she divorced the violinist and married her third husband in 1931. He was a club doorman. In 1936, she divorced him.

Some newspaper articles in the more recent past have some of this story wrong. Richard Kaase was Carl's brother and owned Richard Kaase's

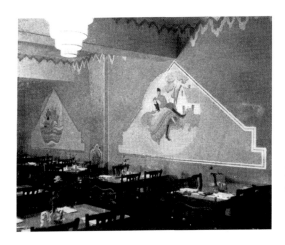

Kaase's dining room. *Courtesy Akron–Summit County Public Library; Waterhouse, Helen S., "Shopping Here & There,"* Akron Topics, *April 1929, vol. 6, page 2.*

Bakery on Lorain Avenue in Cleveland. Richard never owned a business in Akron. Richard's wife, Catherine, did try to sue Marguerite for using the name Kaase's after the death of Carl, but that lawsuit was thrown out, as there was no competition between the two businesses. Also, Carl's father was Heinrich, not Richard, as some articles state.

Chicken in a Nest

For the potato nests:
5 baking potatoes
4 cups peanut oil for deep frying

For the creamed chicken filling:
3 tablespoons butter
6 tablespoons all-purpose flour
I cup chicken broth or stock
I cup half-and-half
¾ pound cooked chicken meat, diced
salt and freshly ground black pepper to taste
chopped fresh parsley for garnish

Peel the potatoes and grate them coarsely. As you do this, keep the grated potato in lightly salted water so it will not discolor. Press the grated potatoes dry on paper towels. Heat the oil in a wok to 380 degrees. Dip a bird's-nest frying basket into the pan to oil it. Take the

baskets apart and fill the bottom basket with the grated potatoes, forming a basket of potato within the wire basket. Replace the smaller basket within the larger and clamp shut.

Deep-fry until golden brown, about 3 minutes. To remove, gently take out the smaller basket. Knock out the potato basket by gently tapping the wire frame upside down on the counter. The potato basket will fall out. Drain on paper towels.

In a small saucepan, melt the butter. Add the flour and cook together to form a roux. Do not brown.

Whisk in the chicken stock and half-and-half. Bring to a simmer, whisking until smooth and lump-free. Stir in the cooked chicken meat and increase the heat. Salt and pepper to taste.

When the chicken filling is cooked through, arrange the potato baskets on a platter and fill them with the hot chicken filling. Garnish with chopped parsley. Makes eight baskets.

Katie Byard, *Akron Beacon Journal*, April 8, 2015, page D4

Kaase's Cinnamon Star Cookies

¾ cup sugar
1 ½ cups margarine
¾ teaspoon salt
2 teaspoons cinnamon
vanilla and maple flavoring to taste
2 eggs
3 cups flour
1 ½ cups walnuts, chopped
cinnamon sugar

Cream together the sugar, margarine, salt and cinnamon. Add vanilla and maple flavoring to taste. Add eggs and mix until smooth. Stir in flour and walnuts and mix until smooth. Roll out dough on floured surface and cut with a miniature star cookie cutter. Sprinkle with cinnamon sugar. Bake on greased cookie sheets at 350 degrees for about 8 minutes.

Jane Snow, *Akron Beacon Journal*, December 3, 2011

KEWPEE HOTEL/HAMBURGERS

Don't let the name Kewpee Hotel/Hamburgers fool you—this was a hamburger joint. It was a chain that began in Michigan during the post–World War I years. By World War II, it had four hundred restaurants in the Midwest, and one was at 15 South High Street (where the art museum is), opened in the old Sol's Drive It Yourself Systems building. Ed Adams was the owner, and Ed Lawrence was the manager. In the early years, the patrons were dealers and dice men from the gambling houses on East Market. Eventually, showbiz people and big bands would stop here after performing downtown.

Lots of local restaurant people got their start here: in the 1940s, James Barbuto was a grill cook and Bob Heath of Kippy's and Dick Heidman, chairman of the local McDonald's franchise, were curb boys. In 1970, Ed Lawrence bought Kewpee and changed the name to Larry's. In 1979, the building was torn down to make a sculpture garden for the Art Institute. So, Larry moved across the street to 16 South High Street. Staff ground fifty to sixty pounds of fresh chuck every day. Prostitutes would come in at night to warm up. Larry's closed in 1989.

KIPPY'S

The Akron Kippy's on South Main Street was opened in 1938 by Bob Heath and his mother, Gail. It was below street level, in the former Ptomaine Tommie's, across from the First National Tower, and was open twenty-four hours. Kippy's on Front Street in Cuyahoga Falls opened in 1940 and closed in 1984. Akron Kippy's closed in 1979. There was also a Kippy's at Norton Center and Arlington Plaza.

This was a no-frills place where you could get breakfast at 2:00 a.m. Heath was also a professional boxer and brought many famous fighters to Akron, including Sugar Ray Robinson for bouts at the Akron Armory.

Who was Kippy? No one! The Heaths liked the sound of the name after getting the idea from Skippy, a newspaper comic strip in the 1930s.

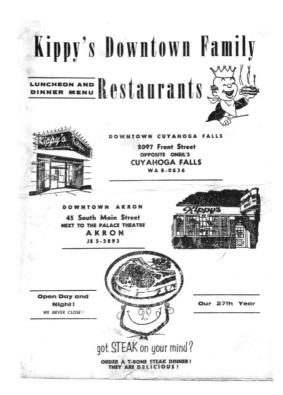

Right: Kippy's menu; *Below*: Kippy's interior. *Courtesy Cuyahoga Falls Historical Society.*

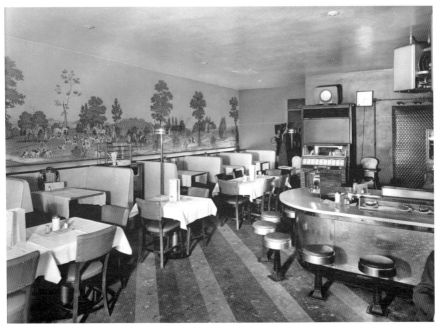

LUIGI'S

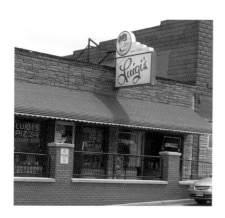

Luigi's. *Author's collection.*

Nick and Rose Ciriello opened Luigi's in 1949 in a former steakhouse at 105 North Main Street that seated sixty people. It is famous for its cheese salad, pizza and spaghetti. It has walls of celebrity pictures—the Four Freshmen; Peter, Paul and Mary; Guy Mitchell; pro bowler Dick Weber; Jay Leno and Bob Costas, just to name a few. There is a mechanical band box above the front door. Mickey Ciriello took over management after his parents died.

MARK RESTAURANT

Mark Figetakis, son of Greek immigrants, owned the Mark Restaurant chain with twenty-three outlets in five states. The chain began in 1964 in a lease agreement with Northeast Ohio–based Brown Derby Inc., of which Figetakis was once vice-president. Relationships became strained, and the two sides ended in a long court fight for control of the restaurants. The chain was in financial trouble in the mid-1970s and involved in many lawsuits regarding unpaid bills. The chain shut down in 1979, and assets were sold to pay off debts. The spots were meat-and-potatoes restaurants.

In 1999, Figetakis and son James opened the Gourmet Café at 12 East Exchange Street. It was a European-style eatery with ethnic food in an upscale environment with an outside eating area. The décor was curry and purple with Hector Vega artwork displayed. It had an elegant, youthful edge. The exotic café closed after only five months after a theft of kitchen equipment. Business had been poor, and two former employees sued for back pay.

A Cleveland contractor also won a judgment against Figetakis for $1,000 on a flooring job. All eleven employees who started in early June were fired or quit by early July. Figetakis received a grant of $10,000 from the city for improvements made to the building.

In 2000, equipment and furnishings left from the Gourmet Café were piled in the parking lot after eviction action was taken due to rent being in arrears. The House of Hunan moved into that location in the same year.

MAYFLOWER HOTEL

When the Mayflower Hotel on Main and State Streets opened its doors on May 18, 1931, the main dining room was called "The Puritan"—and it looked the part. Waitresses wore long, gray dresses and neat white caps of Priscilla Alden. This was the finest hour of Prohibition, of the speakeasy and the magic words at the peephole "Charlie sent me."

In 1934, after Prohibition, the Puritan costumes were sent packing, replaced by Hawaiian grass skirts of a sort. There was a miniature storm projected over a rug-size island. The display was called "Storm over Diamond Head," and it ended the floor show presented for the diners. Shirley Temple and Katharine Hepburn were some of the celebrities who dined here.

By the end of World War II, the dining room had been transformed from the worn bamboo of the "Hawaiian Room" to the plush elegance, glitter and

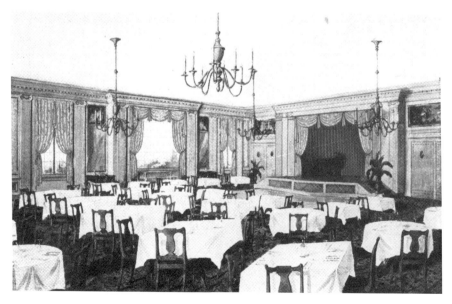

Mayflower Hotel Puritan Room. *Courtesy Akron–Summit County Public Library; "Mayflower Hotel, Puritan Room,"* Akron Topics, *May 1931, vol. 8, page 13.*

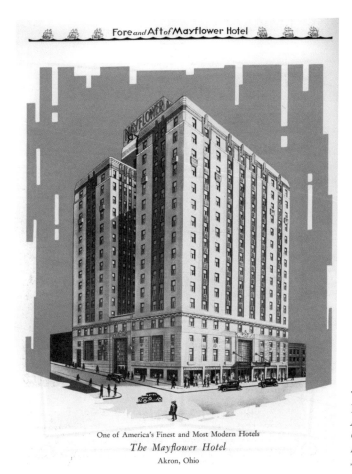

Fore and Aft of Mayflower Hotel

One of America's Finest and Most Modern Hotels

The Mayflower Hotel

Akron, Ohio

The Mayflower Hotel. *Courtesy Akron–Summit County Public Library; Mayflower Souvenir Book.*

class of "The Terrace." In 1956, the legend of the Merry Man, as told in P.P. Cherry's manuscript about the Western Reserve and early Ohio, became the theme of the new "Merry Man" dining room, which looked like the interior of a large log cabin. The dining room closed in 1971, when the Mayflower felt that it no longer needed food service in the hotel.

Being the fifth-tallest building in Akron, the Mayflower currently serves as home to the city's lowest-income residents. Since 1973, it has been Section 8 Housing. There has been talk of making it into upscale housing, as the building itself is in great condition for its age, but rehoming all its residents is an issue.

NUEVO MODERN MEXICAN & TEQUILA BAR

Nuevo Modern Mexican & Tequila Bar was opened in 2014 at 54 East Mill Street by owners Zack and Lisa Hirt. They specialize in modern Mexican food with fresh, locally grown ingredients. The restaurant has artfully designed windows and a patio atop the attached parking deck. In 2016, the owners opened a second, lakefront location in Cleveland.

Neuvo Modern Mexican & Tequila Bar deck. *Courtesy Neuvo Modern Mexican & Tequila Bar.*

OLD HEIDELBERG

Old Heidelberg first opened in the early 1890s in the old Flatiron Building at 116 South Main Street. In the 1930s, it was operated by father and son John and Joseph Kracker. They specialized in German cooking and homemade pastries.

The Old Heidelberg was damaged by a three-alarm fire in December 1945. The fire started in Menke's Restaurant kitchen in the Wilcox Building, which was between the First National Tower and the Flatiron Building. The fire spread quickly, and the water froze in minus-five-degree temperatures. As many as 135 men fought the blaze, using 7,500 gallons of water per minute.

The Old Heidelberg had one of the longest wood bars in the country. It was the original Student Prince Bar of the Chicago 1933 World's Fair. The bar was designed, engineered and built by the Liquid Carbonic Corporation and sold through its Cleveland branch office. The bar is forty feet long and cost $15,000 in 1933. A new bourbon and beer joint, High Street Hop House, opened in 2017 and has the large wood and stained-glass back bar from the Old Heidelberg. Many businessmen patronized the Old Heidelberg in the 1930s.

POLSKY'S TEA ROOM

For ninety-three years, Polsky's Department Store stood on South Main Street across the street from rival O'Neil's Department Store. Polsky's was a five-story building that closed in 1978. The Tea Room was on the mezzanine level and was famous for its chicken pot pie and poppy salad dressing. It was said to be a quiet, relaxing place to go to beat the stress of the day.

Polsky's Poppy Seed Dressing

½ cup sugar
1 teaspoon dry mustard
1 teaspoon salt
⅓ cup vinegar
1 cup salad oil (corn, soybean, etc.)
1 tablespoon poppy seeds
½ medium onion, grated

Combine sugar, dry mustard and salt. Add a small amount of vinegar and blend thoroughly. Add remaining vinegar and oil alternately and beat well. Stir in [grated onion and] poppy seeds. Cover and store in refrigerator.

Jane Snow, *Akron Beacon Journal*, May 16, 2001, page B2

THE RUBBER ROOM

The Rubber Room was in the Portage Hotel, located at 10 North Main Street on the corner of Market. The Portage replaced the Empire House Hotel, a famous stopping point for travelers on the Pennsylvania and Ohio Canal.

The Portage was the only Georgian Revival building in downtown Akron—eight stories tall, 250 rooms and a cost of $600,000 in 1912.

The Rubber Room Bar opened in 1933 and was developed by Cleveland businessman Samuel Real, who came up with the idea. Prohibition had just been repealed. The Rubber Room would gain attention in the Rubber Capital of the World.

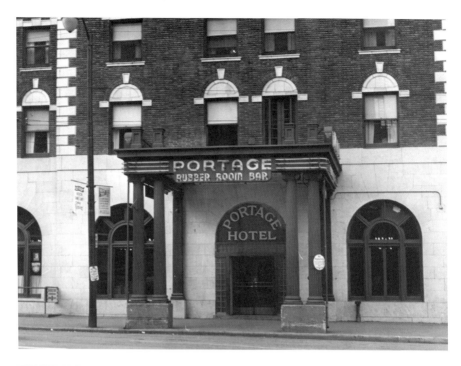

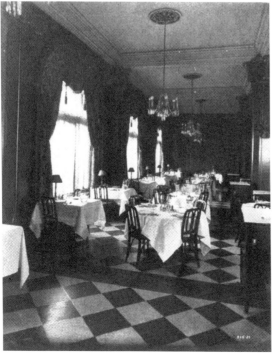

Above: Portage Hotel, Akron, 1957. *Courtesy Akron–Summit County Public Library;* Akron Beacon Journal *Photo Collection, Summit Memory Project.*

Left: Portage Hotel dining room. *Courtesy Akron–Summit County Public Library; Waterhouse, Helen S., "Shopping Here & There,"* Akron Topics, *April 1929, vol. 6, page 37.*

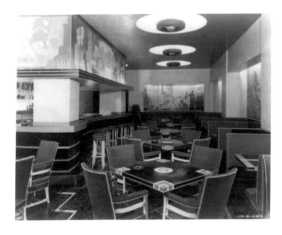

Portage Hotel, Rubber Room.
Courtesy Akron–Summit County Public Library; Restaurant Collection.

The Rubber Room was four tons of rubber. Floors, walls, doors were covered with rubber. Tables were topped with rubber. Booths, chairs and stools were upholstered in rubber. Ceiling lights were rimmed in real tires— one for each of the six manufacturers of tires in Akron. During World War II, when tires were rationed, people tried to steal the tire chandeliers.

The ceiling molding was garden hose green. The floor was multicolored rubber tile with geometric patterns that had insets of Akron-made rubber products—boots, gloves, transmission drives and more. Because of all the rubber, the room was extremely quiet.

Seven large murals were made out of rubber and depicted the development and transportation of rubber from South Africa to Akron factories. Rubber sheeting was cut and bonded together like a jigsaw puzzle to make these murals. Rubber trees flanked the entrance. The Rubber Room was a popular hangout for rubber workers.

The bar closed in 1963, thirty years after opening. The owners thought that redecorating might rejuvenate business and discarded the Rubber Room. Murals were offered to United Rubber Workers and the Akron Art Institute, but the murals were difficult to take apart and put back together, so they ended up in the trash.

The Portage Hotel had closed as a hotel in 1969 and became a nursing home in 1978. The hotel was demolished in 1991.

SANGINITI'S

Located at 207 East Market Street, Sanginiti's was a first-class Italian restaurant that was no longer in a first-class neighborhood by the late 1970s. The dining room décor was of an older elegance, with chandeliers providing soft overhead lighting and red candles decorating every table.

Frank Sanginiti founded the fifteen-thousand-square-foot restaurant in 1952, and it closed in 1990. Sanginiti said that "fast-food restaurants with their damned express window are what were driving [me] out of business." The spot was famous for its lobsters and prime rib. Frank sold the restaurant in 1990 to Joe Cacioppo Jr., who opened Joey's with a condensed menu but closed a year later.

Sanginiti was previously owner of Frank's Café in the 1930s and 1940s. The café opened in 1934 at 911 East Market Street. He sold it to Martha and Harry Nicholson, who opened the Colonial Grille. Frank's Café served T-bone steaks for twenty-five cents!

Frank's brother, Ray, owned Capri Pizza at 810 West Market in Highland Square. He opened it in 1966 and sold it to Mel Todaro Jr. in the late 1980s.

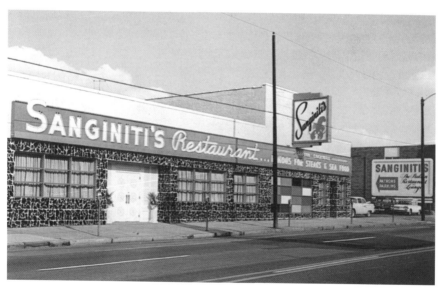

Sanginiti's Restaurant. *Courtesy Akron–Summit County Public Library; Ruth Wright Clinefelter Postcard Collection.*

SCHROEDER'S CAFÉ

Schroeder's Café, at 168 East Center Street, was set amid the campus of the University of Akron. The bar was the oldest in Akron in 1973. Teamster Charles Schroeder came to the United States from Berlin in the 1890s and bought a neighborhood tavern, called the Buckeye Café, from Angeline Emfield in 1905. John Stollmiller originally opened the Buckeye Café in 1903 and sold it to Emfield in 1904. After a while, Schroeder moved the original building farther back on his property and built a new establishment containing a hotel of twenty rooms above the first-floor tavern. The long bar, mirror, booths and tables were kept from the old place. There was an old trough in front of the café filled with water to clean up the mess left by tobacco chewers.

Charles's son, Frank, came into the business with Charles. Wild game dinners were served at Schroeder's. When Frank died in 1954, his daughters, Genevieve "Toots" Peerman and Thelma Galbraith, took over. Galbraith's health declined in the 1970s, and she wanted to sell. The daughters approached the University of Akron about purchasing the property, and a deal was made. Schroeder's closed in 1973. The building was torn down in 1976. The café attracted a lot of Akron University students.

STONE'S GRILL/BRASS RAIL/MR. BILBO'S/LIME SPIDER/ LOCKVIEW

Stone's Grill opened in 1934 in a new building at 207 South Main Street. Jack Sher was president of Stone's, and Samuel H. Stone was manager until 1950. The Grill adjoined the old Stone Malt Company store, which had been in service since 1922. Stone's Grill was styled like an English pub, with rich brown oak, an eighty-five-foot mahogany bar with thirty-two stools and a double row of booths. The Grill seated 132. There was a row of ornamental beer steins. The floor was terrazzo, and there was a stairway to the roof garden. The front of the building was a combination of black vitreous slabs carved and inlaid with silver leaf. The entrance door was oak and curved glass. In 1937, the roof caught fire from sparks from the kitchen ventilator.

In 1971, Stone's was sold to the Brass Rail, which opened in 1971 under William Papaterpos and specialized in Greek food.

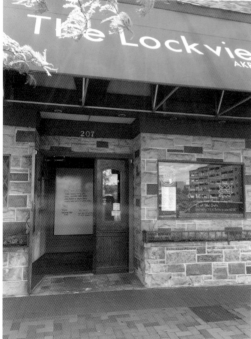

Above: Brass Rail. *Courtesy Akron–Summit County Public Library; Restaurant Collection.*

Left: Lockview. *Author's collection.*

Mr. Bilbo's opened in 1980 and was named after Bilbo Baggins of *The Hobbit*. Inside were nine painted murals of Bilbo himself. Sandwiches were named after characters in Tolkien's books. The restaurant was renovated in 1987 and closed in 2001, citing poor foot traffic on Main Street, panhandlers and being in a blighted area. It was famous for its chicken velvet soup.

Danny Basone opened the Lime Spider in 2001 in the space that used to be Mr. Bilbo's. Basone intended to bring live rock to Akron, and that he did! The Lime Spider was the first club in Akron in years to attract national, independent rock acts. The name Lime Spider was from an obscure '80s rock band from Australia. On evenings when there was no band, he played things like Japanese pop or avant-garde European films.

The walls were decorated with the work of local artists. This was an "avant-garde music club" that seated 250, plus a rooftop bar where amateur disk jockeys could spin anything they wanted. In 2007, the Lime Spider closed, citing financial struggles and falling attendance.

Danny Basone opened the Lockview in 2008. The restaurant specializes in gourmet versions of grilled cheese sandwiches and craft beer. And cream of tomato soup, of course! The Lockview hosts live music on Fridays in the rooftop patio.

Danny Basone opened El Gato Taqueria in 2015 at 209 South Main Street in a small space next to Lockview, which was formerly Hattie's Café. There is a limited menu of Mexican street food—tacos, burritos and more, served cafeteria style. The space seats about forty. The walls are orange and red, and cutouts of Mexican wrestlers are on one wall. Another wall features a mural of a wrestler mask, flowers and spaceships. This work of art was done by Teresa Bosko. Old sci-fi movies play on a television screen.

TANGIER

Ed George Sr. came to Akron from Lebanon in 1929 and opened the first Tangier at 663 East Exchange Street in 1950. On December 26, 1958, the restaurant was gutted by fire. Flames raced from the kitchen stove throughout most of the building. It was a three-alarm fire that destroyed the roof and bar and dining areas. The fire broke out when a porter lit the restaurant's six stoves. There was $100,000 worth of damage.

After the fire, George opened in the current location, which was a small steakhouse called Papa Joe's (not Iacomini's) at 532 West Market. This Papa

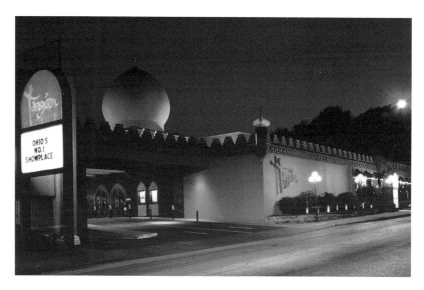

Tangier Restaurant & Cabaret. *Courtesy Akron–Summit County Public Library; Ruth Wright Clinefelter Postcard Collection.*

Joe's was owned by bootlegger Guiseppe Murgida, who obtained a liquor license after Prohibition and opened a café on West Market. Joe died, and his nephew, Julio, inherited the bar. Stan and Johnny Jacobs bought the bar from Julio in 1956 and sold it to Ed George. The Jacobs later went on to manage Mogadore County Club.

The beginning of the Middle Eastern flavor of Tangier started in 1964. The restaurant soon expanded to 2,000 seats and added a nightclub. It became a Las Vegas–style entertainment center, playing host to celebrities, musicians, wedding receptions, business meetings and more. The dining room was added in 1965 and the cabaret in 1975, with a 350-seat capacity. The décor is Moroccan. Walls are full of photos of performers who have graced the stage for the past forty years. Tangier offers eleven dining rooms in more than sixty thousand square feet.

TAVERN IN THE SQUARE/TAVERN STEAKHOUSE

The Tavern in the Square opened in 1975 in Quaker Square at 120 East Mill Street. Ferdinand Schumacher was the founder of the Quaker Oats Company, and he was known as the "King of Oatmeal" in 1886. He once

Quaker Square. *Courtesy Akron–Summit County Public Library; Ruth Wright Clinefelter Postcard Collection.*

had cereal "shot out of a gun." The plant closed in 1971 and was vacant until 1975, when Quaker Square opened. Entrepreneur Jay Nusbaum was instrumental in bringing Quaker Square to life.

The original parts of the old mill were preserved. Brick walls were sandblasted, battered wood floors were brought back to their original sheen and artifacts and equipment were renovated. Quaker Square included more than fifty shops, as well as the Tavern in the Square; REA Express, serving pizza, spaghetti and chicken; and Barnhill's Ice Cream Parlor and Hamburger Emporium. REA Express became the Depot.

The dining room of the Tavern in the Square, in the lower level of Quaker Square, was very attractive, with soft lighting. There were lots of wood and stained-glass dividers. Exposed pipes and a wall of rough stone from the original mill were used in the décor. There were also wood beams and thick carpet. The Continental menu consisted of beef, seafood and chicken.

In 1994, the name was changed to the Tavern Steakhouse with Chef John Pollizi. In 1995, the Tavern closed. It reopened in 1996 and closed again in 1998.

THORNTON GRILL

Located at 263 East Thornton Street, Charlie Cannova, of Cannova's Chili fame, was the owner from 1939 to 1952.

David Finn and Arthur Ackerman were owners from 1952 until 1960. In 1956, there was a $13,000 arson fire. Bob and Karl Angeloff purchased the Grill in 1960 and remodeled the kitchen in 1961. They served kosher food, southern fried chicken, steak, seafood, pizza and Italian dishes.

TREVA/BRICCO

Treva opened at 1 West Exchange Street in 1998. Jeffery O'Neil, Chef Roger Thomas and Diane Robinson, who owned the former Two Sisters Café on Main Street, were owners of this trendy, 160- to 180-seat restaurant with an open kitchen and a wood fire grill. It specialized in seafood and meats. The bar section of Treva was the old State Theatre. In 1999, Chef Jared Kirby, Roger Thomas and Diane Robinson left Treva to open Piatto. In 2000, Treva was sold to Cathy Rinehart, formerly of Moe's in Cuyahoga Falls.

Treva Lemon Shortcake

2½ cups flour
¼ cup sugar
1 tablespoon plus 2 teaspoons baking powder
¼ teaspoon salt
zest of 1 lemon
14 tablespoons butter, cut into pats
1 cup cold milk
2 cups fresh strawberries, sliced and sprinkled with sugar

Combine the flour, sugar, baking powder, salt and lemon zest in a bowl. Stir to mix well. Add the butter pats and cut in with a pastry blender or two knives until it reaches a cornmeal texture. Stir in the milk. Roll out the dough into a 9- by 13-inch baking sheet and bake approximately 20 minutes, until golden brown. Cut into triangles and top with strawberries. Makes eight servings.

David Giffels, *Akron Beacon Journal*, June 11, 1998, page 81

Posh Nightclub opened in 2003 above the former Treva Restaurant at 1 West Exchange Street. Jeff Lorenzo was the owner. Posh served sandwiches, snacks and salads. Arnie "Red" Shapiro was the "executive host" of Posh Nightclub when it first opened until he had an issue parking one night and decided that working at night as his age probably wasn't a good idea.

In 2007, the name changed to Lux Nightclub, but the owner was still Jeff Lorenzo. Lux no longer served food. Lorenzo said he wanted a fresh concept for the club and took it in a new direction.

In 2010, Rubber City Grill opened inside Lux and served salads, wraps, burgers and hoagies. Lux closed. The owner was indicted on fifty counts of tax evasion, one count of conspiracy, unreported income of $746,000 and nonpayment of taxes. Lorenzo was accused of paying some employees in cash and not taxing wages. He also owned the Platinum Horse Cabaret, an upscale adult nightclub on Waterloo Road, which he opened in 1999. Prior to the Platinum Horse, Lorenzo owned Status Nightclub in the same location. Status had teen nights. He currently owns Score Draft Room and Grille at 426 East Exchange. Score caters to students at Akron University.

In 2003, Bricco—a casual restaurant specializing in trendy pizzas, pastas, steak and veal chops—opened in the space that formerly held Treva. Bricco owners are David Glenny, a wine salesman and former manager of the Inn at Turner's Mill, and Chef Adam Smith, formerly of Pucci's Restaurant. The bistro-style Italian eatery seats two hundred and has tile floor, high-top tables in the bar and white tablecloths.

In 2009, Pub Bricco opened in the Valley with outdoor seating, and Café Bricco opened in the Doubletree Hotel in Fairlawn. Pub Bricco is located at

Bricco Bar. *Courtesy Bricco Restaurant.*

1841 Merriman Road. It is a casual pub with a menu consisting of mainly burgers and sandwiches. It also has a jazz room with live entertainment every weekend. In 2014, the downtown location updated the dining area and made kitchen improvements, along with a menu overhaul.

TWO SISTERS CAFÉ

Sisters Diane Robinson and Debbie Scull opened Two Sisters Café in 1993 at 380 South Main Street. It was upscale, with light eats, as well as espresso, latte and afternoon tea. They couldn't get a bank loan for the business, as no one wanted to invest in a business downtown at that time. The sisters came up with more of their own money to make their dream happen.

They were an instant success! Most of their customers worked downtown and would go to Two Sisters Café for lunch. During off-hours, business came from the coffee crowd. Coffee shops were becoming the rage in the early 1990s. They hired bands to play on the weekends.

In 1997, Debbie split and opened the Atrium Court Café. In the meantime, Diane expanded the café and moved closer to Canal Park in a two-hundred-seat location. She revamped the menu to include items like grilled salad, pasta, burgers and more to appeal to the pregame crowd.

In 1998, Diane closed Two Sisters Café and opened Treva at 1 West Exchange Street.

UNIVERSITY CLUB

Dick Brouse and Tom Johnson founded the University Club in 1910 for the purpose of promoting social intercourse and cultural and intellectual improvement, as well as to provide a means of entertainment for its members and their guests. Membership was limited to college men. R.W. Brouse was president, D.W. Harter was vice-president, L.J. Soule was secretary and J.T. Johnson was treasurer.

The University Club was located at the corner of College and Market over Kitty Roehleder's Candy Store. Membership was expanded to include Akron businessmen after a few years. In 1913, they leased the old Seiberling home at 114 East Market Street, and in 1916, plans for a facility on Fir Hill

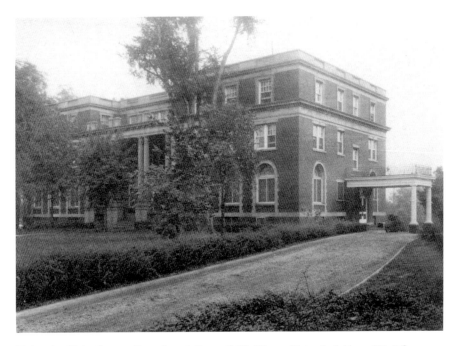

University Club. *Courtesy Akron–Summit County Public Library; "Artwork of Akron, Ohio," Gravure Illustration Company, 1930, part 2, leaf 6.*

were acquired; the large, four-story brick building cost $200,000. It had a thirty-two-room dorm, a library, a lounge, dining, a grill, pool rooms and a tennis court.

Women were not permitted to join until 1975. In 1978, the University of Akron rescued the University Club by turning over its continuing financial problem to the University of Akron Development Foundation. The club only had 420 members at the time of the turnover.

VEGITERRANEAN/DANTE BOCCUZI AKRON/DBA

Chrissie Hynde, rock star and Akron native, opened the VegiTerranean in 2007 at 21 Furnace Street in the lower level of Testa Builders' Northside Lofts. The restaurant was mired in debts, legal trouble and dissolved business partnerships. Dan Duplain of Fideli's Restaurant in Canton was co-owner of the VegiTerranean, and Chef Scott Jones, also of Fideli's in Canton, was executive chef and co-owner. The restaurant specialized in a combination

of vegetarian and Mediterranean foods blended together. The ninety-five-seat restaurant was a hip, cool, upscale place with three patios and outside dining for an additional ninety-five.

Testa Builders filed suit against the restaurant for back rent. There were twenty judgement liens against VegiTerranean going back to 2009 by the Ohio Department of Taxation and the Ohio Bureau of Workers Compensation for unpaid tax and insurance premiums. The restaurant closed in 2011.

VegiTerranean Heirloom Tomato Salad with Crisped Capers

¼ cup plus 1 teaspoon extra virgin olive oil
1 tablespoon capers, drained
3 pounds mixed heirloom tomatoes, cut into ½-inch wedges
2 tablespoons fresh basil chiffonade (cut in thin ribbons)
sea salt and freshly ground black pepper

Heat 1 teaspoon of the olive oil in a small sauté pan over medium-high heat. Add the capers and cook until crisp, 1 to 2 minutes. Remove to a paper towel. Place the tomatoes in a large bowl. Drizzle with the remaining ¼ cup of oil, add the basil, season with salt and pepper to taste and gently toss to coat.

Divide the salad between 6 plates. Sprinkle the capers on the salads after they're plated so they stay crisp. Makes 6 servings.

Chef Scot Jones
Lisa Abraham, *Akron Beacon Journal*, September 8, 2010, page D3

Chef Dante Boccuzzi partnered with builder Joel Testa to open a restaurant in the former VegiTerranean location in Akron's Northside Lofts in 2012. Dante Boccuzzi Akron is located at 21 Furnace Street and seats ninety inside. Chef Torsten Schultz had an upscale, seasonal menu. A sushi bar was added in 2013. The bread baskets are made of melted long-playing records shaped into bread baskets. Most of the records are of the Pretenders as a tribute to Hynde.

In about 2013, Morgan Yagi became a co-owner in DBA, and Chef Schultz left in 2014. The restaurant is now owned by Byte Dining Group (Joel Testa and Dante Boccuzzi), which in 2015 opened the Northside Speakeasy

in the Northside Courtyard by Marriott next door to DBA. The speakeasy is a small bar with private areas and a hidden door. Boccuzzi grew up in the North Hill and has several successful restaurants in the Cleveland area.

WESTERN DRIVE-IN

Christe Phillios opened the Western Drive-In across from the Akron Beacon Journal Building at 47 East Exchange Street in April 1949. The restaurant seated 120, and many rubber workers along with college students could be found at the 24/7 restaurant, which served good food at reasonable prices. There was a large horseshoe counter in the middle of the restaurant with tables and booths filling the perimeter. It was famous for its thirteen-inch Coney dogs and Big Tex Burgers.

In April 1957, Jim Goumas bought the business and expanded to two more locations—one on North Main in North Akron and one on Cleveland-Massillon Road in Richfield. In February 1971, Goumas closed the doors, as business had declined with fewer people downtown, mainly due to the rubber companies beginning to pull out of town.

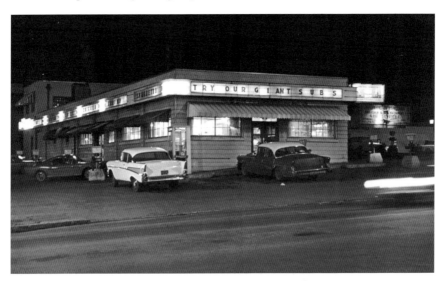

Western Drive-In, 1968. *Courtesy Akron–Summit County Public Library; Akron Beacon Journal Photo Collection, Summit Memory Project.*

BLUE CANYON KITCHEN AND TAVERN

Co-owners and brothers Robert and Val Voelker opened the upscale lodge-style Blue Canyon Kitchen and Tavern at 8960 Wilcox Drive in Twinsburg in 2004. They set out to create a destination restaurant with six dining rooms, beamed cathedral ceilings and antler chandeliers in the ten-thousand-square-foot restaurant constructed entirely of logs. Co-owner and chef Brandt Evans, formerly of Kosta's in Tremont, has a creative, American

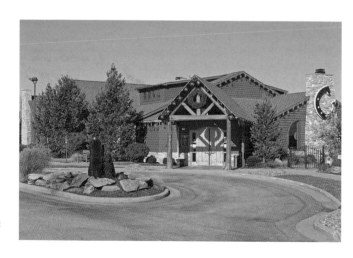

Blue Canyon
Tavern exterior.
*Courtesy Blue Canyon
Tavern.*

cooking menu that includes seafood, steak, pasta and game. He has teamed up with a local farm to grow produce specifically for the restaurant in the summer.

Blue Canyon Pan-Roasted Chicken Thighs
with Roasted Autumn Vegetables

3 butternut squash, peeled and cut into 2-inch cubes
2 medium carrots, diced
6 ribs celery, diced
olive oil
salt and pepper
8 to 10 boneless chicken thighs
2 cups shiitake mushrooms
4 shallots, minced
1 clove garlic, minced
sprig of fresh thyme
3 cups sweet coconut milk
2 tablespoons red curry paste
2 cups chicken stock
2 tablespoons unsalted butter

Preheat oven to 400 degrees.

Peel and dice squash, carrot and celery into 2-inch pieces. Place vegetables on a baking sheet, drizzle with olive oil and sprinkle with salt and pepper. Roast vegetables in oven about 45 minutes until soft.

In a large cast iron skillet or sauté pan, heat 2 tablespoons olive oil on medium-high. Place chicken thighs in pan, skin side down. Season with salt and pepper. Don't overcrowd the pan with chicken. After chicken is cooked on one side, flip over and sauté thighs on other side.

Add shallots, mushrooms, garlic and thyme to pan and continue cooking about 5 minutes longer. Add coconut milk, red curry paste, [butter] and stock to pan. Mix well to form sauce. Finally, add roasted vegetables to pan.

Serve with risotto or mashed potatoes. Makes 6 to 8 servings.

For the next day, recycle the leftovers into two other dishes: Remove the chicken from the dish. Take sauce and vegetables and puree into Coconut Curry Vegetable Soup and freeze for another day. When ready

to serve soup in the future, garnish it with some grilled shrimp. Slice remaining chicken and place it on top of iceberg or Bibb lettuce leaves for Asian Chicken Lettuce Wraps. Top the chicken with some julienne carrots, cucumber, radishes and pickled ginger for sushi that have been sprinkled with some rice wine vinegar and sesame seeds and roll them up. Serve the wraps with sweet soy sauce or Thai chili sauce for dipping.

Lisa Abraham, *Akron Beacon Journal*, September 3, 2009, page D2

BOULEVARD RESTAURANT AND TAVERN

The Boulevard Restaurant and Tavern was founded in 1939 by George Neemer. It was passed down to his nephew, Mike Jasser, in the late 1960s. Jasser passed it down to his nephew, Fares Jasser, in 1981. It is located at 435 Chestnut Boulevard in Cuyahoga Falls. The interior has lots of the original woodwork. It is known for its fish fries.

CANTEEN

Thomas MacDonald owned the Canteen at 1612 State Road, near the High Level Bridge in Cuyahoga Falls, since 1928, until he sold it to Garrett "Doc" Brown and William N. Williams in 1948. Oliver Jewett, head of J.

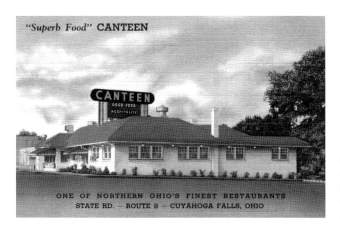

Canteen Restaurant. *Courtesy Akron–Summit County Public Library; Ruth Wright Clinefelter Postcard Collection.*

Catering, operated the Canteen at that time. In 1958, Doc Brown renamed it the New Brown's Restaurant before selling it to Nick and Charles Anthe that same year.

On November 25, 1962, a fire started in the basement, where there were nine rooms (including a bakery) in the forty-year-old building. The fire became superheated in all the false walls from many years of remodeling. The fire department couldn't put out the flames. There was $200,000 worth of damage.

CIRIELLO'S TAVERN/CY'S/CAFÉ FELICE

Samuel "Cy" Skolnik opened Cy's Restaurant and Cocktail Bar at 2467 State Road in Cuyahoga Falls in 1950. He retired, and Bob Ross was the operating manager until 1962.

Angelo Ciriello opened Ciriello's Tavern at this location in 1962. He sold his share of the restaurant to partners John Brasko and James Fleming in 1974 after his only son was killed by a hit-skip driver. He said that he could no longer play the happy host. He started working for the Witness Assistance Program.

In 1975, Brasko and Fleming filed for bankruptcy. In 1976, Christ and Florence Arshinkoff and sons opened Arshinkoff's Tavern. They previously owned Hillcrest Gardens and the Times Grill by Goodyear at 606 South Main. Ciriello's saw several different owners until Felix Otero opened Café Felice in 1997 after doing a building renovation. He had large front windows installed. Photos of Cuyahoga Falls from the 1930s through the 1950s hung on the walls. The menu included deli sandwiches, soup, salad, bakery items, espresso drinks, frozen yogurt, muffulettas and paninis. Café Felice was said to be a blend of coffeehouse, café and cafeteria. There was blues and jazz on weekends.

Café Felice Philly Steak Muffuletta

1 giant boule crusty Italian bread
16 ounces frozen fajita vegetables, cooked
6 ounces Italian dressing
8 ounces provolone cheese, sliced

4 ounces pepperoncini, drained and sliced
1 ½ pounds roast beef, thinly sliced

Cut off the top of the bread and scoop out the center. Cook the vegetables according to the package directions and drain. Mix with the Italian dressing. Layer half of the vegetables on the bottom of the bread, then add the cheese, pepperoncini and roast beef, topping with the rest of the vegetables. Put on the top, wrap tightly in plastic and weigh down (with a breadboard and a weight). Refrigerate with weight on for 4 to 24 hours. To serve, cut into wedges. Makes eight servings.

Connie Bloom, *Akron Beacon Journal*, November 20, 1997, page 21

DARBY'S ON 59/FRANKIE'S CAFÉ

Darby's. *Author's collection.*

Darby's on 59, located at 2764 Front Street in Cuyahoga Falls, uses locally grown ingredients from area farms in its eclectic menu of carefully crafted dishes. The space has a rustic ambiance and an outdoor patio. Darby's opened in about 2012.

There have been many owners over the years, beginning in 1931 when Philip Neuman was the proprietor and it was called the Barbecue Bungalow. Neuman shot and killed a twenty-one-year-old would-be burglar. By 1933, it had become the Lagoon, owned by Lee Marshall and Francis Ashcraft—it was reported that burglars stole a slot machine from the Lagoon in 1933.

It was Meekin's Café in the early 1940s and Frankie's Café in the 1950s and 1960s, owned by Frankie and Vicki Swartz. The Swartzes retired in 1964.

DELUCA'S BISMARK ITALIAN RESTAURANT/GOLDEN DRAGON/ HENRY WAHNER'S LAMPLITE

DeLuca's Bismark Italian Restaurant was founded by Jack DeLuca and Frank Cassidy in 1935 at 690 North Main Street in Akron's North Hill. Cassidy had previously owned the Bismark Restaurant at Main and Mill Streets during Prohibition. Patsy Pace played there during the 1960s.

In the 1940s, Jack did a Saturday morning radio show called *Koffee Kapers*. It was a local fun and games show to promote the restaurant. In 1952, DeLuca "invented" frozen pizza and developed it into a business that actually outlived his restaurant. It eventually died when his handmade product couldn't compete with the large, fast-food operators.

On April 14, 1953, a fire started in the stockroom in the basement and caused $12,500 worth of smoke and water damage to the dining room of the twenty-year-old building. Deluca and Cassidy sold the restaurant in 1956 to C.L. Davis, and Davis leased the restaurant to Phil Wong, former owner of Wongs on Bowery. Wong named this restaurant the Golden Dragon.

In 1967, it was purchased by Henry Wahner, who opened Henry Wahner's Lamplite Restaurant. He brought German cooking to Akron. It was country style with a rustic German air. He sold the restaurant in 1979 and opened Henry's Lamplite in Kent a few years later.

Henry's Lamplite Schnitzel

4 pork cutlets from a boneless loin, or butterfly chops
flour, to coat
2 eggs
¼ cup milk
bread crumbs, to coat
oil
lemon, for seasoning

Pound out the meat, then dip cutlets into flour to completely cover. Mix eggs and milk; dip cutlets into mixture. Then dip into bread crumbs and press crumbs into the meat. Deep-fry in oil. (If using a skillet, pour about ½ to 1 inch of oil in the pan.) Serve with lemon wedges for seasoning. Makes four servings.

Charlene Nevada, *Akron Beacon Journal*, April 11, 1993, page 106

DI'LULLO'S/DI'LULLO'S TRATTORIA

The original location of Di'Lullo's was at 153 East Cuyahoga Falls Avenue. Then in 1946, John Di'Lullo opened Di'Lullo's Restaurant at 2485 State Road in Cuyahoga Falls with his brothers in a building that he had built. In 1960, the restaurant was redecorated by Marvin Interiors with walnut paneling and a rust and green color scheme, along with floral arrangements, green drapes, rust-colored booths and a mahogany bar.

They remodeled again in 1978 with carpet and white tablecloths, muted gray and rose drapes. This is about the time that John stepped aside to let son Dominick take over. The name changed to Di'Lullo's Trattoria. Di'Lullo's closed in the mid-1980s. It was famous for John's baked chicken, Di'Lullo's Sautéed Garlic Shrimp with Capellini, the spaghetti sauce and the Mussels Marina.

Di'Lullo's Sautéed Garlic Shrimp with Capellini

¼ pound capellini or other thin-noodle pasta
½ cup broccoli florets
½ cup fresh sliced zucchini
½ cup yellow squash, sliced
¼ cup fresh mushrooms, sliced
½ cup extra virgin olive oil
4 whole cloves garlic
8 fresh shrimp, deveined and shelled
salt and pepper to taste
fresh Italian parsley, for garnish
freshly grated Romano cheese, for garnish

Cook pasta in salted water until done but firm, not soft. Set aside.

Steam or blanch vegetables in boiling water a minute or two, just to slightly soften and preserve the color. Remove from heat source and set aside. Put olive oil in a skillet; crush garlic and brown. Add shrimp and cook for a few seconds. Add the pre-blanched vegetables. Continue cooking until shrimp are done. Salt and grind in pepper to taste.

Remove pan from heat and set aside. Add pasta to the frying pan and toss with shrimp-vegetable mixture. Also mix in 2 tablespoons of the pasta cooking water.

Sprinkle with fresh Italian parsley and Romano cheese. Makes one serving.

Katie Byard, *Akron Beacon Journal*, April 8, 2015, page D4

DOWNTOWN 140

Downtown 140 opened in 2004 in the lower level of an historical building at 140 North Main Street in Hudson. It used to be a gift shop called the Mole Hole. Chef Shawn Monday, who left Turner's Inn, and Kurt Nygaard are co-owners. In the beginning, they had a jewel-like tapas bar.

The restaurant has exposed brick and sandstone foundation and a hand-hewn stone wall. Downtown 140 offers fine dining in its overstuffed chairs with a seasonal menu. The restaurant seats fifty.

ERNIE'S BAR AND LOUNGE

In 1979, Ernie's Bar and Lounge was opened at 1757 State Road in Cuyahoga Falls in the former Colonel's Place by Ernie Poulas Sr. and his son, Ernie Jr., who was also a chef. The restaurant was famous for prime rib and Ernie's Salad. Poulas also owned the old Chestnut Bar at 803 North Main Street in Temple Square and Ernie's Rib Room at 1970 West Market Street, where Ken Stewart's is currently. The State Road location changed owners many times over the years. In 1981, it was Barney's Raw Bar. In 1982, it was Kask & Kleaver. In 1984, it was the Speak Easy. And in 1985, it was the Southfork Rib Room.

FISHER'S CAFÉ AND PUB

In 1958, George Fisher opened Fisher's Service Center (now Café) at 1607 Main Street in Peninsula at the former site of a Model T Ford dealership. It still has the straight-back wooden booths of the '50s. Now it is a no-frills sports pub that seats forty and serves wings, burgers and comfort food. There is an outdoor patio with live music on the weekends.

The kitchen was expanded in 1994 when the Cuyahoga Valley Park put in a bike trail, and it got more hikers and bikers as customers. The café is now owned by the son of George Fisher, Dick Fisher, and the general manager is George's grandson, Rich Fisher.

HUDSON CROSSINGS RESTAURANT/HUDSON BREWING/SHERWIN PARTY CENTER/LI'L JOE'S PUB/THE PUB

Jim Capwell opened Hudson Crossings in 1999 in the twenty-seven-thousand-square-foot building at 5416 Darrow Road that was formerly Hudson Brewing, Sherwin Party Center and Li'l Joe's Pub. The Crossings had a microbrewery, pub menu, formal dining, meeting rooms and Sunday brunch. Li'l Joe's Pub was opened in 1973 by the Iacomini family and sold around 1985 to Ed Barr, who turned it into the Pub.

INN AT TURNER'S MILL/THE ROSEWOOD GRILL

The Inn at Turner's Mill opened in 1989 in a historic 1852 property in Hudson at 36 East Streetsboro Street. The owners were brothers Todd and Brad Buchanan and their father, Ralph. Turner's Mill was originally a grain mill. The restaurant featured American cuisine with seasonal menu changes. The interior of the restaurant has hand-hewn stone walls and beamed ceilings. The Inn closed in August 2007.

Rosewood Grill dining room. *Courtesy of Rosewood Grill.*

After additional construction, including a new bar and kitchen, Hospitality Restaurants opened the Rosewood Grill in 2009, making it a historic mill with urban-chic décor and an outdoor fire pit area. The interior has warm textures and rosewood tables. The name comes from a Michael Stanley album, *Rosewood Bitters*. (Michael Stanley is a Cleveland singer/songwriter/musician who was known for his "heartland rock.")

JIMANDY'S/DALE'S/GOLDEN GOOSE/BLUE DOOR

JimAndy's was opened in 1948 by James Andrew Tisci and his brother-in-law, Speranza "Andy" Silecchia. It was located at 1970 State Road in Cuyahoga Falls. It had a waitress by the name of Betty, who sang all day. It was known for its Chicken-in-a-Basket.

In 1981, Dale Woy bought the restaurant and opened Dale's. Dale's was famous for its cabbage soup. It sold thirty to forty gallons of cabbage soup per week! Dales was sold to Judge James Barbuto in 1986. Barbuto left Dodie's to buy Dale's.

Dale's Cabbage Soup

2 large heads cabbage
1 large onion
1 can (29 ounces) tomato puree
1 can (18 ounces) tomato sauce
⅓ cup sugar

Remove and discard tough outer leaves of cabbage. Chop head into bite-size pieces, discarding core. Chop onions. Place all ingredients in a large soup pot. Add water to cover ingredients; stir. Bring to a boil, reduce heat and simmer uncovered for about an hour, or until cabbage is tender and soup is as thick as desired. Add water for a thinner soup. Serves at least 20.

Jane Snow, *Akron Beacon Journal*, March 22, 2000, page 36

In 2009, it became the Golden Goose, and Mike Bruno was a baker there. The Golden Goose was a coffee shop with European pastries. In 2011, Bruno bought the restaurant from his mother-in-law, Ann Marie Leipley. After a quick remodel, he opened the Blue Door, serving local, fresh, seasonal food. The kitchen is under the leadership of Chef Torsten Schultz, formerly of DBA. In 2014, the site began doing dinner on top of breakfast and lunch. The lunch menu consists of sandwiches, soup, quiche, crepes and omelets. The Blue Door discontinued dinners in 2017.

JIMMY'S CAFÉ/CHOWDER HOUSE

Artist and ex-pro football player Jim VanHoose opened Jimmy's Café at 2028 Chestnut Street in Cuyahoga Falls in 2000. It was more of a coffeehouse than an eatery, serving crepes, cakes and muffins along with an array of gourmet coffees. The place was more about art—it was full of paintings, photography, sculpture, stained glass and more. Every inch inside and out was artwork. Jimmy even painted the chairs and tables.

In 2004, he expanded the kitchen and put in a hardwood floor. The dining room seats sixty-three. He began serving New Orleans muffalettas, po'boys, jambalaya and red beans and rice. He built a stage for entertainment.

Chowder House. *Author's collection.*

In 2005, his health was failing, and he sold the café to Carla Jarvis. It closed in 2009 and was reopened as the Chowder House.

Chef Louis Prpich kept the artwork that was the hallmark of Jimmy's. The Chowder House has no liquor license, so customers bring their own beer or wine and pay a small corkage fee. In 2010, Chef Prpich began a partnership with a farm so he could get locally grown heirloom tomatoes for the café. In 2011, Chef Prpich opened Sugo Modern Italian Bistro in the former DiLullo's at 2485 State Road, where they served ossobuco and

ahi tuna, among other items. In 2011, he hired Chef Michael Ferris, but Sugo closed in 2012.

The Chowder House is known for its clam chowder and seafood dishes.

Chowder House Café Heirloom Tomatoes and Prawns

8 ounces bacon (6 to 8 strips), diced
2 lemons (preferably organic), well-washed
½ cup dry white wine
1 teaspoon salt
2 cups prawns, peeled, deveined and tails removed
6 medium to large heirloom tomatoes
1 cup fresh raspberries
1 cup baby arugula, stems removed
⅔ cup classic vinaigrette (recipe follows)

In a large skillet over medium-high heat, place the bacon with ½ cup of water. When the water evaporates, turn the heat down to low and stir until the bacon is evenly browned. Place the bacon bits on a paper towel to drain and cool.

Juice the lemon and remove the zest in strips. Finely chop the zest.

Place a 2-quart pot over high heat and add the lemon juice, 2 cups of water, the wine and salt. Bring to a boil. Have a strainer and a medium-size bowl of ice water nearby. Place the prawns into the pot and poach for 2 minutes. Remove using a strainer or slotted spoon and quickly immerse them in the ice water to stop the cooking. Drain and give them a few minutes to cool further, then chop them into small pieces and set aside.

Wash the tomatoes, raspberries and arugula. Core and cut the tomatoes into ¾-inch dice.

In a serving bowl, add the bacon, lemon zest, tomatoes, raspberries, arugula and prawns. Add the vinaigrette and toss to mix. Serve cold in a bowl or platter. Makes 6 servings.

Classic Vinaigrette

1 cup olive oil
¼ cup red wine vinegar
1 tablespoon lemon juice
pinch sugar
pinch Kosher salt
pinch ground black pepper

Place all ingredients in a jar with a lid and shake to blend.

Note: Fresh jumbo shrimp can be substituted if prawns aren't available.

Lisa Abrahams, *Akron Beacon Journal*, September 8, 2010, page D3

LACONI'S/RETZ'S LACONI'S II

In 1934, Dominic and Velia Laconi purchased a brick building in a residential neighborhood (that had been a bakery in 1929) at 547 Sackett Avenue in Cuyahoga Falls. They offered free spaghetti on Tuesday nights and nickel beers from a barrel. They didn't sell their signature pizza until 1945, when Laconi's introduced pizza to Cuyahoga Falls.

In 1969, they added a dining room. Their son, Sam, took over management in 1970. Sam retired in 1999 and sold the building to the VFW. The restaurant was reopened in 2011 by Steve, Gary and Vicki Retzer. Sam gave them the recipe for pizza and the sauce. The name is now Retz's Laconi's II.

LADD'S

Jim and Mary Procaccio opened Ladd's in 1949 on the corner of State Road and Phelps Avenue at 2346 State Road in Cuyahoga Falls. It offered curb service in the early years. When it closed in 1999, it had the original sixteen stools and three tiny booths and speckled countertops.

People came from all over for the foot-long Coneys with a secret red sauce. Jim Brown, Johnny Mathis and Robert Stack were customers, to name a few.

Ladd's exterior. *Courtesy Cuyahoga Falls Historical Society.*

It was also known for its Big Laddie, which was a double cheeseburger made with ground chuck—*not* hamburger.

In 2000, Randy McDonald and Bill Gagnon reopened it as Ladd's Diner after painting and putting in new flooring, but it soon closed.

LAVITA'S GARDENS/DONTINO'S

Dontino's. *Author's collection.*

Dominic Ross owned LaVita's Gardens, located at 555 East Cuyahoga Falls Avenue, from 1933 until his death in 1964. LaVita's Steak Sandwich, with secret hot peppers, was the specialty. Alfred and Mildred Andrea owned the restaurant from 1964 until 1975, when Vince Dontino Maltempi bought LaVita's with his son, Carlo, and opened Dontino's. It is known for its homemade pasta, and it still has LaVita's Steak Sandwich on the menu. Dontino expanded the restaurant, but it still has red-and-white checkered tablecloths.

LEFEVER'S RIVER GRILLE/THE RIVER BRASSERIE AND BAR/ SAMIRA'S/BURNTWOOD TAVERN

LeFever's River Grille was opened in 1999 at 2291 Riverfront Parkway, on the Cuyahoga River in Cuyahoga Falls, by Robert LeFever, who left the Fairlawn Country Club to run LeFever's with co-owner/developer, Louis Ferris. The restaurant sat 275 inside and 105 on the patio.

The name changed to the River Brasserie and Bar in 2009 after it was sold to Chef Michael Fiola and David Slaught, formerly of the Carousel Dinner Theater. It was known for using locally grown, sustainable food.

Samira's Restaurant opened in that spot in 2010 with Chef Michael Fiola and owner Nick Dadich. The restaurant offered great views of the river and the falls. In 2013, it closed and reopened as the Burntwood Tavern with owners Bret and Michael Adams, who own the Burntwood chain of restaurants. The deck that overlooks the river is still there. The menu is casual with steak, fries and sandwiches.

Burntwood Tavern. *Author's collection.*

LERELAIS PARISIAN/FRENCH COFFEE SHOP

Parisians, Serg and Daniele Mandelman opened LeRelais Parisian at 1917 East Bailey Road in Cuyahoga Falls in 1968 in a small, twenty-six-seat space serving French onion soup, crepes and sandwiches. They sold the restaurant in the early 1970s to Nancy Rockhold, who moved to a former laundromat in a small strip-shopping plaza at 1911 Bailey Road. The new space sat seventy-five and served the same menu. The name changed to the French Coffee Shop. Lorin and Belle Harman purchased the coffee shop in 1984 and sold it to Max and Amy Fiffick in 1997. The coffee shop closed in 2014. It was famous for its French onion soup that had gobs of melted Swiss cheese on top.

LUJAN'S BURGER BOY

Ron Lujan opened his first restaurant in 1956. In the end, he had twelve restaurants—one in Cuyahoga Falls, one in Tallmadge, one on South Main and so on. Lujan's was one of the cruising spots like the Varsity, Hungry I and the Flame in the '60s. People would park, buy a coke and sit there all night. Or they would make the rounds driving through all the cruising drive-ins.

Lujan's had a commissary in Cuyahoga Falls where it processed its own meat and baked and cooked there. Then a refrigerated truck would deliver to

Lujan's Burger Boy exterior. *Courtesy Cuyahoga Falls Historical Society.*

all stores. In 1961, Lujan's used five tons of meat and one thousand pounds of coffee per week.

In 1966, Lujan's bought the Hungry I at 1714 Portage Trail in Cuyahoga Falls from founders Edward and James Fulkman. Char King bought Lujan's in 1979.

MARCELITA'S/OAK AND EMBERS

Marcelita's Restaurant was opened at 7774 Darrow Road in Hudson in 1978 by Marcelita Arregui de McNeill, an immigrant from Mexico. She first opened a one-room eatery in the middle of nothing and added onto it over the years. In 2008, she sold the restaurant to a friend, but the transition didn't work out well. Marcelita's closed in 2015. It was the first non-chain Mexican restaurant in the area.

Marc and Gretchen Garofoli bought the restaurant and did major remodeling. It is now 8,500 square feet and seats 350. It has a new Bourbon bar and an outside patio with a fireplace. They opened Oak and Embers in 2017, serving baby back ribs, beef brisket, pork shoulder, sausage and chicken wings.

MARCEL'S

Partners Maiden E. Hall, Richard Vogel and Charles Marcellus Moreland purchased what was then Hauser's Tavern at 2225 State Road in Cuyahoga Falls on September 11, 1952, under the partnership named HMV Company. Hauser's Tavern was owned by Michael Houser and his wife, Eva Platz. The Hausers lived above the tavern. The tavern had a jukebox and a pinball machine.

This location was originally owned by Carl Graefe, president of Chestnut Hill Cemetery. Graefe was a real estate developer in the 1920s and constructed a building on this property as his office. The funny thing is that Carl Graefe ate at Marcel's all the time. The building was converted into a barbecue restaurant in the early 1930s. It was remodeled and enlarged in 1933 and became Hauser's Tavern, a neighborhood pub. The exterior was still a Spanish style like the original real estate office.

Marcel's Restaurant exterior, 1952. *Courtesy Bob Hall.*

Steve Davis leased the tavern from the Hausers, remodeled some more and called it Davis' Restaurant.

Dick Vogel was the owner-chef of Marcel's, partner Maden Hall ran the luncheon crowd and partner Marcel ran the dinner crowd to closing. Cuyahoga Falls artist Jack Richard painted several works for the restaurant. Several artists hung their artwork in the restaurant from time to time, including Mark Moon.

The January 28, 1954 *Falls News* reads as follows:

> *Three men have developed one of the finest restaurants in northern Summit County during the few short months that they have been in business at Marcel's on State Rd. Dick Vogel, M.E. Hall and Marcel Moreland are the three partners in the thriving enterprise. Probably the biggest reason for their success is that all of the men have been in the restaurant business all of their lives and have learned through long experience at some of the finest restaurants in the country how to put out a really good dinner at a reasonable price.*

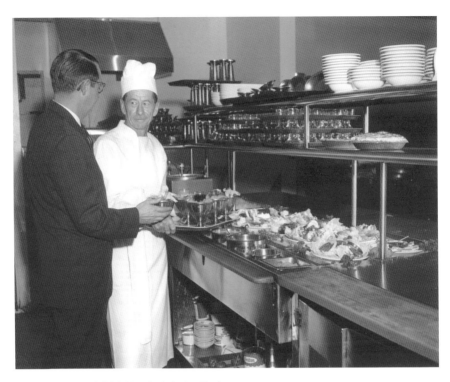

Marcel with Chef Dick Vogel. *Author's collection.*

For instance, one of the owners, Dick Vogel, probably has more friends in the northern part of the county than any other restaurant man in the area. He was associated with Lake Forest Country Club for 10 years, two years with the famous Gruber's Restaurant in Cleveland. He has also been at the Latin Quarter and Ghent Rd. Inn of Akron. Through these associations, Dick has made many friends because of his polite, old-world manners and his ability to make patrons comfortable and see that they enjoy their food. Many people, some as far away as Cleveland, come to see Dick at the restaurant. He has also worked at such other famous places as the Ambassador Hotel in Washington, D.C.

The three men have all worked together at various times in the past. M.E. Hall and Marcel Moreland were partners in a restaurant once before in Barberton until they had to go into the Army. [Marcel was a mess sergeant for four years in the South Pacific.] Vogel and Moreland worked together for 7 years at the Lake Forest Country

Club and at the Rainbow Room of the now defunct Semler's Tavern in Cuyahoga Falls. [The Rainbow Room was fine dining and dancing versus the Castle Club, which was gambling. It opened in 1937.] *Consequently, when the three men formed the present company, they could feel that the partnership brought together some of the best men in the business, because they knew each other's capabilities.*

M.E. Hall, in considering some of the reasons for the phenomenal success of Marcel's, said, "We have tried our best to put out a really good meal at a price attractive to the Cuyahoga Falls family. Our steaks and beef cuts are the best. And there are very few places in the country where a really good steak dinner can cost as low as $2.75. Of course, we are always looking for an even better way to do things and ways to serve our customers even better."

Over the years, Marcel's kept expanding the building to the north, overtaking the auto parts store. HMV Company sold the restaurant to attorney Ernie Genovese on November 3, 1975. Genovese ran it as Art's

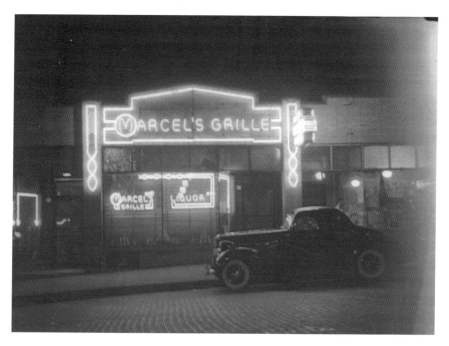

Marcel's Grille exterior. *Author's collection.*

Hall's Restaurant, 1941. *Courtesy Akron–Summit County Public Library;* Akron Beacon Journal *Photo Collection; Summit Memory Project.*

Place, and it was demolished in 2004 and made into a parking lot for an auto parts store.

Marcel's was known for its scampi and prime rib and for consistently good food. The horseshoe-shaped Zodiac bar was the place to be in the 1960s.

Before Marcel's Restaurant, Moreland owned Marcel's Grille in 1943, located at 663 East Exchange Street. By 1943, Moreland was off to the South Pacific for World War II. Maden Hall owned Hall's Grille and Club at 661 East Exchange Street in the late 1930s and early 1940s. In 1939, burglars locked themselves in the basement and carried off a sum of money. When Hall came to work the next day, he found the basement door forced open and the money gone.

Hall and Moreland owned the Hallmark Grille at 1571 Kenmore Boulevard from 1947 until 1951.

MOE'S/KIT KAT/PETER SWALLOW'S

Maureen Schneider opened the chic Moe's Restaurant in a 1916 building at 2385 Front Street in Cuyahoga Falls in 1998. The dining room seats forty-six and the bar seats twenty-four. This is the former site of the Kit Kat Lounge most recently and Peter Swallow's Liquor from the 1920s to the 1960s. Swallow's was opened by Peter Economow. In 1950, officials talked to him about the fact that he rented out the two upstairs rooms to known gamblers, Willie "Sonny" Lea and Riley Jerrel, who opened a bookie joint there with race wire service and a dozen telephones.

Schneider was a caterer for ten years before opening Moe's and also worked at Rockne's in Cuyahoga Falls for seventeen years and the Peninsula Nite Club and Foley's. She gutted the interior, restored the original tin ceiling and decorated the dining room in a soft rose with black and white, a sort of 1960s look. Photos of egg multiples are hung on the walls— they number the tables. At Moe's, you will find white linen tablecloths and black linen napkins on each table with fresh flowers. The décor is said to be "space age." Chef Kathy Rinehart worked up a great menu to begin featuring veal chops for fine dining and bar food.

In 1999, the chalkboard menu, with weekly menu changes, began featuring seasonal cuisine such as lamb and asparagus in the spring and squash and pumpkin in the fall. The menu was inventive and thoughtful.

In 2002, new chef Mark Simak took over the kitchen after Jeff Allgood left to open his own restaurant, Tailgators, in Canton. Simak was a line chef at Grappa's. He featured Asian fusion and wasabi. Then, in 2003, Chef Jared Kirby, who was formerly at Treva and the Galaxy, came to Moe's and featured a menu that was more European with some East/ West touches. In 2006, Schneider opened Moe Joe's, an upscale coffee and sandwich shop in the Park West Medical Building in West Akron.

In 2012, Kevin Francek became chef. The chalkboard menu changes monthly, now, instead of weekly.

PIATTO/PIATTO NOVO

Chef Roger Thomas founded Piatto in downtown Akron near Canal Park, at 326 South Main, in 1999. He had been chef at Ken Stewart's Restaurant, the Wine Merchant and Sixteen Eighty before this. In 2006, he moved his restaurant to the Sheraton in Cuyahoga Falls and named it Piatto Novo. In 2014, Chef Thomas left Piatto Novo to become chef at Fiore's Italian Steakhouse at 85 Montrose West Avenue in Copley, on the "hill."

RESERVE INN/VINE AND LAGER

Leon and Minnie Wagner opened the Reserve Inn in Hudson in 1958 at 30 West Streetsboro Road in the former Mericola's Restaurant, owned by John and Rose Mericola, who filed for bankruptcy in 1962. Rose also owned the Cloverleaf. The Wagners previously owned the Tip Top in Stow and Twinsburg in the late 1940s.

Son Dennis took over after Leon died in 1993. The restaurant had traditional American décor, with works of local artists hanging on the walls, and sat 160. Many of the Cavs would stop in after a game—Coach Lenny Wilkens and NBA star Bill Russell, to name just a few. The Reserve Inn was known for its chicken Waldorf. The restaurant closed in 2012 and opened under new ownership as Vine and Lager. Vine and Lager has craft beers and uses local ingredients.

RUSSO'S

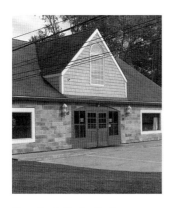

Russo's. *Author's collection.*

Chef Dave Russo, formerly of Liberty Street Brewing, opened a new 2,500-square-foot, ninety-seat restaurant in 2002 at 4895 State Road in Peninsula. The restaurant has an open kitchen and serves a menu that is half Cajun, half Italian. Russo is a North Hill native who spent eleven years in New Orleans kitchens. He studied under the likes of Paul Prudhomme and Emeril Lagasse. Russo's Italian heritage is apparent with some of his grandmother's recipes on the menu. His website states that they specialize in Creole food and Italian soul food.

SILVER PHEASANT

Rick Hallet opened the Silver Pheasant in 1978 at 3085 Graham Road. Hallet also owned the Dry Dock in Fairlawn in the 1980s. Chef Randy Jenkins was at the Silver Pheasant from 1983 to 1989. In 1990, Hallet offered a children's menu, as he felt that many people were bringing their children to the restaurant with them. The Silver Pheasant closed in 2003.

STOW SMORGASBORD

The Stow Smorgasbord was opened in 1939 by Lillian Jae at 3983 Darrow Road in Stow on the former site of the old Motor Inn, a popular roadhouse owned by L.E. Stanford. In 1929, a gas explosion completely destroyed the Motor Inn, and two people were injured. The main section of the Inn was a frame dwelling more than one hundred years old.

The Smorgasbord had more than one hundred dishes, four dining rooms with white tablecloths and a fireplace. Lillian died in 1949 at the age of forty-nine. Her brother, Leonard Simon, and his wife operated it for several years until her son, Hugh Jae, assumed control in the 1950s.

In the 1970s, John Baran and his wife, Ann, a former Playboy bunny, were the owners. The restaurant closed in 1973.

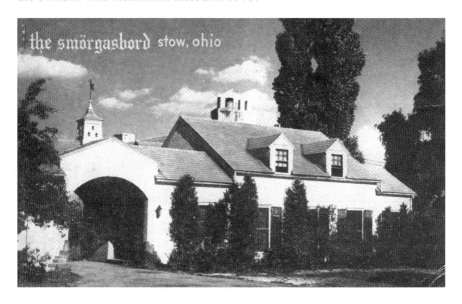

Above and opposite: Smorgasbord, Stow, Ohio. *Courtesy Akron–Summit County Public Library; Ruth Wright Clinefelter Postcard Collection.*

THE SURREY

Charles "Chic" Seminerio built the Surry Restaurant at 80 West Streetsboro Road in Hudson in 1964. This was a very upscale restaurant. Samie previously owned the Chanticleer in Fairlawn. In August 1966, the Brown Derby opened in the old Surry Building. It displayed a large steer replica for the opening.

TED AND MARY'S/HUDSON'S ON THE GREEN

In 1946, Francis Thomas built the restaurant at 80 North Main Street in Hudson and called it Thomas'. He sold it to Howard Creekbaun, who opened Howard's, and then Jack Peace purchased it and called it Peace's. Mary and Ted Pavlantos bought it on their honeymoon in 1951, and son Mike took it over in 1976. When the Pavlantoses bought it, it had pinball machines and jukeboxes. It was a coffee shop with a lunch counter, a place to go for morning breaks if you worked in downtown Hudson.

In 2006, John Altomare and sons J.J. and Kevin, known as the "three foodies," opened Hudson's Restaurant on the Green in the former Ted and Mary's in Hudson. This is a casual eatery with burgers, comfort food and an extensive martini menu. In 2012, they opened a Copley location, but it closed in 2015.

TIP TOP DRIVE-IN

Located at 3428 Darrow Road in Stow, the Tip Top has been around since the late '20s, when it was a local family barbecue pit. It has seen many changes since then. It became the Flag Pole, Captain Jack's, Around the Clock and Charlie's. The building has grown in size since the 1920s too! This is a casual place to go for breakfast or lunch.

TOMMY'S CAFÉ/TOMMY BRUNO'S STEAKHOUSE

Tommy's Café was opened in 1939 at 2225 Front Street in Cuyahoga Falls by Tommy Bruno. The café closed in 1978. The name was changed to Tommy Bruno's Steakhouse in the 1960s.

There was an apartment upstairs from the café that was turned into the "Skylight Room." It was run by Anita, Tommy's wife, and was said to be the place where attorneys and bankers went for lunch.

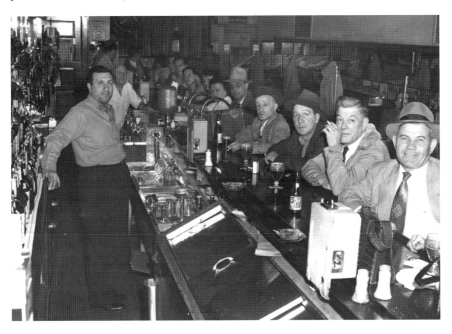

Above: Tommy's Café interior; *Left*: Tommy's Café menu. *Courtesy Cuyahoga Falls Historical Society.*

TRIPLE CROWN

The Triple Crown opened in 1982 as B.J. Finigan's at 335 South Main Street in Munroe Falls. Developer Ed Barr purchased the restaurant in 1984 and remodeled it, giving it a rustic, lodge-like interior. David Nadar was the chef. Ed Barr passed away in 1994, and his widow, Pat Box, ran the spot until it closed in 2007. The twenty-thousand-square-foot restaurant was known for prime rib, pasta, seafood and steak. The menu was very large and made one wonder how the kitchen could cook all those dishes well. It was shut down for a while in 1995 after an oven fire. In 2010, new owner Debora Parz of Hudson reopened the 342-seat restaurant, but it closed again in 2011.

VUE

The Vue Restaurant opened at 49 Village Way in the First and Main Shopping District in Hudson in 2005. Opening co-owners were Chef Shawn Monday and his wife, Tiffany. The restaurant was a white tablecloth fine dining place. Co-owners Butch Bartlett and Paolo Giogi closed the restaurant in 2010.

Chef Monday, Tiffany and co-owner Michael Swartz opened the Red Door in the former Vue space in Hudson. The restaurant serves comfort food in a fine dining atmosphere. Next door is the Flip Side, which offers gourmet burgers.

Eastern Summit County Restaurants

EDGAR'S AT GOOD PARK

Chef Louis Prpich opened Edgar's at 530 Nome Avenue overlooking Good Park Golf Course in 2005. Prpich sold the restaurant to Debbie Robinson in 2007. The restaurant seats 110 inside and 48 outside. It has jazz music on the weekends.

Co-owners David Jursik and Steve Tarr owned the restaurant for a while. Chef Glenn Gillespe currently owns the restaurant that replaced Crocker's. The name came from J. Edgar Goodpark—thus, it should have been J. Edward Goodpark Golf Course, but items were already printed.

GUS' CHALET/CREO'S CAJUN & CREOLE STEAKHOUSE

Gus Kanarias emigrated from Greece in the 1960s. He learned the restaurant business from the Anthe brothers and opened Gus' Chalet at 938 East Tallmadge Avenue in 1974. This was a favorite spot for local politicians to hang out. It was nothing fancy—just the basics, with a Continental hint. There were more than fifty entrées on the menu. Every diner received a complementary relish dish and kidney bean salad.

Gus had a Kodak memory: once he met you, he never forgot you. He was famous for Gus' Toast, Greek specialties and sauerkraut balls. The restaurant closed in 2014 as Gus was eighty and there was no one to take over. In 2014, Creo's Cajun & Creole Steakhouse opened with owner Nadia Outkidout. Creo's menu includes po'boys, steaks, chops, seafood, chicken and pasta.

Gus' Puffs

4 ounces grated Parmesan
2 cups mayonnaise
1 ½ onions, minced
1 loaf day-old white sandwich bread

In a bowl, mix together half the cheese with all the mayo and onion.

Use whole slices of bread, or use a large cookie cutter to cut a round from each slice of bread. Place slices or rounds on cookie sheets and broil till toasted.

Flip and spread with mayonnaise mixture. Sprinkle additional cheese on top. Return to oven and broil till puffs are golden brown.

Jane Snow, *Akron Beacon Journal,* June 8, 1988, page 46

LEON'S/GROUND ROUND

Leon's Restaurant was opened in 1943 by Leonard Kubalak at 1349 East Tallmadge Avenue on the corner of Britain Road. His father, Leon, bought what was Fairview Lunch and gas station in 1933, just after Prohibition ended. He obtained one of the first liquor licenses. An addition was added in 1937, and the family lived upstairs. This was a 325-seat restaurant. Leon's closed in 1979, and a Howard Johnson's Ground Round opened in its spot. McDonald's was built there later.

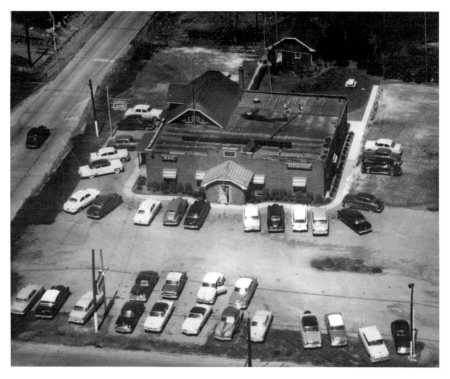

Leon's Restaurant, Akron, Ohio. *Courtesy Akron–Summit County Public Library; Shorty Fulton Collection.*

NEW ERA

Lucille Juric opened the New Era Restaurant at 10 Massillon Road in 1928, serving Yugoslavian food in a seventy-seat restaurant. In 1982, Mary and Mitch Likic bought the restaurant. Lucille was Mary's aunt. In 2005, they tore down the old building and built a new one that seats two hundred, still keeping the casual atmosphere of the old one.

New Era is famous for its pigs in a blanket, sauerkraut, chicken paprika, goulash and the glass-fronted display case loaded with pastries and strudel. On Monday nights, the 1960s band the Counterpoints, starring Gary Parker, plays to a crowd of seniors dancing like it's 1964.

ROOSEVELT LOUNGE

The building at 313 Darrow Road and Newton Street that dates back to the 1920s was linked to folklore surrounding the 1930s criminal "Pretty Boy" Floyd. He was a notorious bank robber. Floyd earned his nickname for his habit of primping frequently. Charles Floyd supposedly crashed on occasion in one of the apartments upstairs from the Lounge. Floyd was an Akron regular who lived in a house at 447 Lodi Street, where he was arrested in 1930 while living under the alias of Frankie Mitchell. Floyd was later killed in a 1934 shootout with the Federal Bureau of Investigation in East Liverpool.

Pretty Boy Floyd's funeral was said to have been the largest funeral ever in Oklahoma, where he was from. Huge, unruly crowds came to see the rites for the slain gunman. They say that somewhere between ten and forty thousand people jammed the roads leading to the rural cemetery. Floyd was only thirty at the time of his death and was wanted in six states for bank robbery and murder.

Clifford Keen owned the Roosevelt Lounge from 1979 until it closed and the building was torn down in 2002 due to disrepair.

THACKER'S

Marvin "Pop" Thacker, former rubber worker, along with Terry and Dayton Thacker, opened a restaurant in 1921 in a one-story concrete block building on East Exchange near Bowery. It was called Peppy Service Lunch originally. In 1926, they moved to 1300 East Market and Kelly Avenue, where Thacker's became a beacon for Goodyear workers and East High School students. That building was replaced in 1939 by a larger one of yellow brick and tile.

The signature sandwich was the Thackerburger. Grease in the hamburgers was a guarded secret. Mustard was provided but no catsup. Catsup didn't mix well with the grease it used. It sold burgers by the sack. It was the first in Ohio to offer five-cent hamburgers.

Thacker's closed in 1980 after nearly sixty years in business.

Southern Summit County Restaurants

ANTHE'S ON THE LAKES/PRIME 93

Charles Anthe got started in the restaurant business in the 1940s downtown Akron as a busboy at the Garden Grille with his brother, Nick. They then went to the suburbs as a team before each going solo. Charles and his wife, Pauline, operated Anthe's Restaurant at 4315 Manchester Road, New Franklin, in Portage Lakes from 1969 until they retired in 1979. This was an elegant setting at the hilltop location with a gracious porch that wraps around the building and live music in the lounge.

Their sons, Jim and John Anthe, operated the restaurant after Charles retired. They also operated Anthe's Fairlawn for a while in the 1980s at 2914 West Market Street in the old Themely's Restaurant building. In 1991, John sold his share of Anthe's to Jim. And in 1995, John took over the Fox Chase Inn in Twin Lakes. John bought Sixteen Eighty in 2000. In 2008, longtime restaurateur John Bahas of the Waterloo Restaurant bought Anthe's and renamed it Prime 93.

ART'S PLACE RESTAURANT AND LOUNGE

Lawyer Ernest Genovese purchased Art's Place Restaurant and Lounge at 20 Waterloo Road from former owner Art Corice in the early 1960s.

The original building on the site was a big wooden hotel called Mickey Bertsch's Inn, owned by Frank Mickey Bertsch, who died in a car crash in 1933. The Inn was raided in 1929, and ninety-three pints of Canadian beer were confiscated. Art Corice bought the hotel, and it burned to the ground and was replaced by a smaller structure known as Art's Place. Illegal gaming went on in the basement. Corice was a reputed slot machine operator and had dealings with Tony Masino in the 1930s.

In 1932, Al Shumacher of Silver Lake and Ed Thompsett were held in jail on highway robbery charges for their participation in the $800 holdup of Corice at his home in the Portage Lakes.

Genovese invested thousands of dollars in remodeling the building. In 1988, he expanded the 135-seat dining room to seat 200. He remodeled the kitchen and added three restrooms. The décor was mixed. They had maple captain's chairs and modern fixtures with drawings of old cars on the walls. The building façade and landscape were spruced up. Art's Place was known for its bean soup. In 1996, Dodie Varca and Jenny Morris bought the Waterloo Road location.

Genovese purchased Marcel's Restaurant on State Road in Cuyahoga Falls in 1975. His stepchildren, Donna Daulton and David O'Brien, inherited the restaurant on State Road from their mother, Betty Genovese, and the State Road restaurant closed in 2002 and was torn down in 2004 for a parking lot for an auto parts store.

Art's Place Bean Soup

1 pound dry navy beans
2 quarts cold water
4 ham hocks
salt
6 whole peppercorns
1 bay leaf
1 medium onion, sliced
pepper

Thoroughly wash beans. Place in a soup kettle and cover with the cold water. Bring to a boil and boil gently for two minutes. Remove from heat, cover and let stand one hour (do not drain).

Add ham hocks, one-half teaspoon salt, peppercorns and bay leaf. Cover and bring to a boil. Reduce heat and simmer until beans are tender, about 3 to 3½ hours. Add onion during last half hour of cooking.

Remove ham hocks. Mash a few of the beans with a potato masher to thicken soup. Cut ham from the bones and return to soup. Season to taste with salt and pepper. Serves six.

Katie Byard, *Akron Beacon Journal*, April 8, 2015, Page D4

BLUE SWAN/LAKES BLUE SWAN

The Blue Swan Drive-In was opened in 1948 by Dick Heidman. There were two locations: 428 Portage Lakes Drive and 1999 South Main Street. The Blue Swan was famous for its Ole Shanty Town Chicken and pizza burgers. In 1967, Heidman became involved with local McDonald's franchises and sold the Blue Swan to Mike Martin, who turned it into a catering business. The Lakes Blue Swan was the first restaurant in the county to have curb service for boats.

CANNOVA'S GRILL

Cannova's was located at 1143 Lake Shore Boulevard in a small, remodeled, paneled house that used to be a speakeasy. It was located across the street from the former Summit Beach Amusement Park until Charlie Cannova became the owner. It was known for its Daddy's Ross' Chili. Chef Daddy Ross made the chili at the old Thornton Grill in the 1930s. The Thornton Grille was owned by Cannova from 1938 until 1955, when he opened Cannova's Grill. The chili at Thornton's Grille had no beans in it. Ross later cooked at Cannova's Grill, and the recipe was passed on after his death.

You could order the chili in various forms: 1) Chili Mac—spaghetti and chili meat topped with longhorn cheese; 2) Chili—red beans and

meat; 3) Four-Way Chili—spaghetti, lean meat and cheese; 4) Chili Meat—bowl of meat and nothing else; and 5) Chili Meat with Cheese. You could order chili wet or dry, and a basket of Zesta crackers was served with every bowl of chili. There were corked beer bottles full of homemade hot sauce on every table. There were ten hot chili peppers in each bottle. Cannova's made eighty pounds of chili every day. It used no water and no tomatoes. It was a favorite place for politicians, executives and rubber workers.

Joseph and Katherine Messer bought the restaurant in the 1960s from the Cannovas. Longtime waitress Pearl Woods bought the restaurant in 1976 but was shot in the chest and killed by a robber in 1982. Three men were arrested and sentenced to life. Her daughters operated the restaurant after her death until Elie Takla bought it in 1986, and it was closed in 1993 after a drug raid. The restaurant was the site of several shootings, stabbings and fights since the killing of Pearl Woods.

IDO CAFÉ

Michael Kostoff opened the Ido Café in 1943 at 1537 South Main Street. The café is named after the street that runs alongside it. The Ido Burger is part of the heritage of the café, and it is what attracted a following of Firestone workers when it first opened. When asked what the secret of the Ido Burger is, the answer is simple: fresh meat daily. Burgers have been on the menu since 1943.

ROSE VILLA

The Rose Villa was established in 1928 in Portage Lakes. Portage Lakes is a group of glacial kettle lakes and reservoirs, and the name comes from an old American Indian portage path that connected the Cuyahoga River, which flows north to Lake Erie, and the Tuscarawas River, which flows south to the Muskingum and then into the Ohio River. The Ohio flows into the Mississippi River, which empties into the Gulf. So, the American Indians could navigate from Lake Erie to the Ohio River and eventually to the Gulf with only an eight-mile portage.

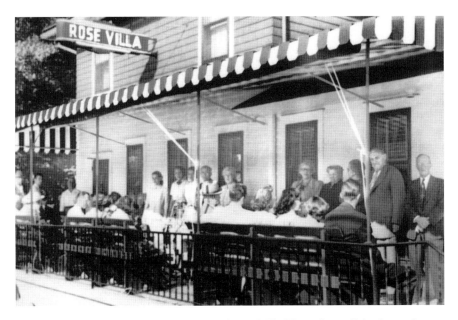

Rose Villa Restaurant. *Courtesy Akron–Summit County Public Library; Portage Lakes Community Photograph Project.*

The area now is a popular fishing and boating area with a state park and a great party place. But I digress. The Rose Villa quickly became famous for its fresh perch dinners. In 1974, the restaurant was sold to Domenic Fana, who was born in Sicily and came to Akron in 1955. He added some Sicilian specialties to the menu, and his wife, Anna, added great pies.

The Rose Villa is one of the few places in Portage Lakes without a liquor license and is known as a family-oriented restaurant.

356TH FIGHTER GROUP/WHISKEY RANCH COUNTRY SPORTS SALOON AND WOOD FIRE GRILL

Specialty Restaurant Corporation of California opened the 356th Fighter Group Restaurant in 1986 at 4919 Mount Pleasant Road in Green. This was a military-themed restaurant with a picturesque view of Akron-Canton Regional Airport. The restaurant was 9,500 square feet and sat 200 with a cabaret for dancing; an outside patio had a total capacity of 465. The 356th had floor-to-ceiling windows for great views of planes

landing and taking off. Patrons could listen to control tower conversation on tableside headsets. Soundtracks of World War II–era newsreels played in the restrooms. The restaurant was built to resemble a bombed-out English farmhouse with crumbling walls, sandbagged bunkers and old farm wagons on the lawn, as well as some vintage army Jeeps and ambulances outside too.

Copper pots were placed at the fireplace hearths. There were wood ceilings with dark beams and memorabilia posted everywhere—pin-up calendars, snapshots and recruiting posters. Waitresses wore Red Cross outfits. The menu was a mix of American, Californian and Continental.

In 1992, Bob and Tina Scolfield bought the Fighter Group restaurant, brought back white tablecloths and put fresh seafood on the menu. In 2012, they hired a new chef, Walter J. Halchak III. The restaurant closed in 2014, a weak economy to blame.

In 2015, the building was sold to Whiskey Ranch Partners, formed by Mark Norris and Mark Milkovich. They were planning to open a sports bar. In 2016, the Whiskey Ranch Country Sports Saloon and Wood Fire Grill opened as a barbecue, bourbon and country music place. It also has a game room.

WATERLOO RESTAURANT

In 1957, John and Kathy Bahas purchased a small drive-in restaurant on Waterloo Road. They converted the drive-in to a two-hundred-seat sit-down restaurant, and now their son, John, runs the restaurant. In 1958, it was famous for a "gallon of chicken"—twelve pieces, French fries or onion rings and a whole apple pie for $3.50. Then there was the bottomless cup of coffee, the Foot of Fish, the Big Apple Pie and the Long John Milkshake. The Waterloo serves breakfast all day and night, and it also has patio dining.

The Waterloo is famous for its handmade pies and sauerkraut balls. It sells about twenty thousand sauerkraut balls over the holidays. The restaurant is family-style, nothing fancy. Bahas purchased Anthe's on the Lakes and renamed it Prime 93.

Waterloo Coconut Cream Pie

2 boxes (4-serving size) vanilla pudding mix (not instant)
3 tablespoons coconut flavoring
1 cup frozen whipped topping, thawed
½ cup shredded coconut, lightly toasted
¼ cup blanched slivered almonds, lightly toasted
2 (9-inch) baked pie shells
additional whipped topping

Prepare both boxes of pudding according to package directions. Chill several hours or overnight.

Several hours before serving, place pudding in a mixer bowl and beat until smooth and fluffy. Fold in coconut flavoring and the 1 cup whipped topping. Gently fold toasted coconut and almonds into filling.

Pour filling into baked pie crust. Swirl whipped topping over filling and lightly sprinkle with toasted coconut and almonds, if desired. Chill thoroughly. Makes 2 pies.

Note: Toast coconut and nuts by spreading on separate baking sheets and baking at 350 degrees just until coconut begins to turn golden, and for nuts, for about 3 to 4 minutes, until they're crisp but have not changed color.

Katie Byard, *Akron Beacon Journal*, April 8, 2015, page D4

YOUNG'S

Young's evolved from a saloon and grocery in a little log house with a Sample Room (bar) at 2744 Manchester Road overlooking Nesmith Lake. It was founded by German immigrant John Young in 1850 on land for which he paid $50. Young sold fried blue gill and whiskey. His wife started opening the house to the public and charged $0.25 for dinners. She soon raised the price to $0.35 and then to $0.50 since it was so popular. During World War I, she charged $2.50.

Louis, son of John Young, opened the hotel in 1905 after tearing down the log cabin. In 1907, a fire that started in the ladies' room entirely destroyed the hotel. It was rebuilt in 1908.

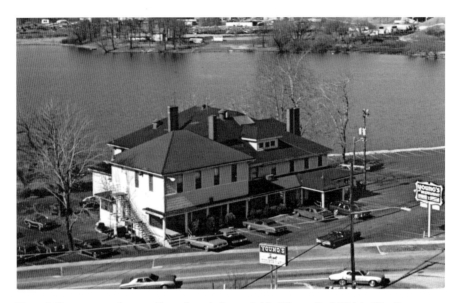

Young's Restaurant. *Courtesy Akron–Summit County Public Library; Ruth Wright Clinefelter Postcard Collection.*

They kept frogs in a pen in the lake because there was no refrigeration at the time. When frog legs were ordered, someone would run down to the lake to get some. In 1930, fire damaged the entire roof to the tune of $5,000. This fire was blamed on defective wiring or a defective flue. In 1981, a fire started in the kitchen.

William, son of Louis, was a hunter and had a wild game dinner every year with game that he got locally and by going out west for moose and such. There was no advertising. The dinner grew from ten people the first year to nearly five hundred people in just three years. The dining room closed in the mid-1990s, as business had slowed down. The bar was still open, and food was served there.

Young's was famous for family-style dinners in the 1940s. Later on, it was famous mainly for steaks. Richard Brown, great-grandson of John Young, closed the building in 2004, and the City of Akron purchased it in 2007. It was in a state of disrepair and was torn down. Summit County still mourns the loss of Young's. Young's was the oldest eating establishment in Summit County.

BUCKET SHOP/BERRODIN'S CAFÉ/RAY'S PLACE

In 1934, Louis and Kathryn Berrodin founded Berrodin's Café at 816 West Market Street in Highland Square, in the building that was Highland Catering. It was the middle of the Great Depression and Prohibition; bars were illegal. Was the place a speakeasy? Probably. The café was the "nineteenth hole" for Portage Country Club. After Prohibition ended, they changed the name to the Bucket Shop.

Rubber workers came to the Bucket Shop after their shifts. The Berrodins put little tin buckets filled with popcorn on every table—hence the name! In 1962, Louis Jr. took over the restaurant due to his father's ill health. In the 1970s, Louis Jr. had enormous speakers installed. Neighbors complained about the noise. Louis Jr. installed a door to the left of the main entrance so that people coming and going wouldn't let the sound of the music go out into the neighborhood. The Bucket Shop was a hangout for musicians.

In 1989, neighbors were still complaining of noise and litter coming from the Bucket Shop. During that same year, Louis Jr. was charged with felony drug use, as police found him at 3:00 a.m. behind the bar with Oxycodone. He pleaded innocent. Charges were eventually dropped because of a technical error. He had the painkiller on a legal prescription.

Louis Jr. died in 2000. He had withdrawn from management of the bar due to health issues, allowing his children to run it. In 2007, the Bucket Shop closed. It reopened that same year as Ray's Place, owned by Ray Nemer. Ray's Place is moving to a new location in 2017.

CAFÉ RAPALLO/MACHINE GUN KELLY'S/DUSTY FROG

In 1990, Chef Mark Burton joined Café Rapallo (owned by Andre Andreoli), an upscale Italian restaurant across from the Weathervane Playhouse in Liberty Commons, at 1272 Weathervane Lane. The menu was Northern Italian, with some Southern Italian dishes. It was a small, intimate restaurant. Burton previously worked at Carnaby Street Inn in Hudson.

In 1993, Debra Kelly bought the café and opened a '30s-style restaurant that had waiters dressed like mobsters, wanted posters on the walls and music of the era. It was called Machine Gun Kelly's and was sold in 1997 to Michael Maly and Alfred and Susan Schultz, who opened the Dusty Frog, which was cigar friendly and had bands for dancing.

CARNABY STREET

David Szucs and his school buddy Tony Petrarca were co-owners when Carnaby Street Restaurant opened in 1979 at 1343 Weathervane Lane. The dining room seated 130 and was traditional Victorian, intimate and cozy. The owners and decorator Dave Brennan went to New York, St. Louis and Dallas to search for authentic Victorian antiques with which to decorate. The front doors were from a New Jersey brownstone. Dave Brennan designed the bar and stained-glass windows in the three-tiered dining room. The booths were crimson plush velvet.

In 1983, it shifted its focus from a well-rounded selection of seafood to steak and potatoes after Chef George Lenos left. In 1987, the restaurant was newly renovated with a blue and cream décor and stained-glass dividers. Randy Jenkins was the chef. He was previously at the Silver Pheasant in Stow. The restaurant closed in 1992, when Ed Barr was the owner.

THE CHANTICLEER/GHENT ROAD INN/FANO'S/BREAD & THREAD/THE GRATE/DRY DOCK/NATALIE'S

The building at 25 Ghent Road was a grocery store in the 1930s and came a long way from that beginning. In 1931, A.L. Smith was the owner of the Ghent Road Inn and was arrested and charged with possession of liquor. Liquor bottles were found under tables and in patrons' coat pockets. This was still during Prohibition. Smith was again charged, that same year, with possession of liquor and permitting guests to bring in liquor.

In 1935, the sheriff fired tear gas bombs into the building to disperse people at 2:00 a.m. The Inn was charged with selling liquor after 1:00 a.m. In 1936, Mike Masino, brother of Tony, owned the Inn, and slot machines were hijacked from the site. Mike owned a bookie joint at 56½ East Market in 1930, and in 1934, he wanted to open a night club at 45 South Main, serve liquor and food and call it the Merry Go Round, which was actually his brother Tony's place. In 1942, the police gave them an ultimatum: suspend gaming operations or give up their liquor license. Tony Masino was gambling at the Inn.

Michael Adella owned the Inn from 1943 to 1946 and did some remodeling in 1944 with a South American Room in what was the Viesta Room. In 1947, fire destroyed the Inn. There was a loss of $100,000. In 1952, liens

were filed against Adella for income, cabaret and miscellaneous taxes in the amount of $13,175.

The Chanticleer was a posh dining spot at the corner of Ghent Road and West Market Street in the 1950s and 1960s and was owned by Michael LoCicero and Charles Sami. Debbie Reynolds and Eddie Fisher stopped for dinner in 1955.

Frank Barnett of Lannings opened a deluxe sandwich shop called the Grate in this location in 1970. It grilled sandwiches over coals. From 1972 to 1973, it was the Bread and Thread, where there was food, wine and men's clothing. It was the Dry Dock in 1979 and changed to the Old Dock during 1980–82. In 1983–95, it was Mountain Jack's.

In 1996, Natalie's opened in the former Mountain Jack's with an upscale décor with warm tones of burgundy, mauve and hunter green. Natalie Woy was the owner. There were plaid padded chairs, thick green carpeting, mauve patterned wall coverings and white tablecloths with shaded candles at each table. There was also a cigar/cognac room. Chef John Krummrich ruled the kitchen. The restaurant was too expensive for the area, and in 1997, it went up for sale.

THE COVERED BRIDGE

The Covered Bridge Restaurant was located at 1925 North Cleveland/ Massillon Road. Jean Falor began with a custard stand in 1956, and it grew into an ice cream parlor. In 1971, it became a restaurant named for the nearby Everett Covered Bridge. The Everett Covered Bridge, which crosses Furnace Run, is the only remaining covered bridge in Summit County. The bridge played an important role in the nineteenth-century transportation system, aiding farmers by providing a functional road to get to the canal to ship products to Cleveland.

The story of the origins of the covered bridge go like this: Farmers John Gilson and his wife had to cross Furnace Run when returning home from visiting friends on a winter night in 1877. A winter storm caused the water to rise, and ice obstructed the ford they normally used. While going around the ford, Mrs. Gilson was thrown into the stream, and Mr. Gilson was dragged by his horse into deeper water; his body was not recovered for four days. Mrs. Gilson was rescued, and the bridge was built because of this accident.

Covered Bridge. *Courtesy Akron–Summit County Public Library; Restaurant Collection.*

Falor and her husband, Bill, sold the restaurant to Frank Klienes in 1986. The restaurant was decorated to resemble the inside of a covered bridge. Murals of tree tops peek over the rough wood paneling on the side walls. The two ends of the room were framed with beams to form the entrance and exit of the bridge, against a backdrop of murals of mountains and trees. The ceiling was beamed, and red lanterns hung from rough-paneled support columns. The Covered Bridge closed in 1992.

THE DANISH SMORGASBORD

Everett Farnam was the son of John and Mary Everett Farnam, who were among the earliest Connecticut settlers to come to Ohio. Everett is said to have been a brilliant man, ahead of his time; he rotated crops before others understood the benefits, he quoted the Bible and he planted thousands of trees when forest clearing was common.

He was also a bit odd, requiring callers to make three trips around the circular driveway to signal that their intentions were friendly. Not sure

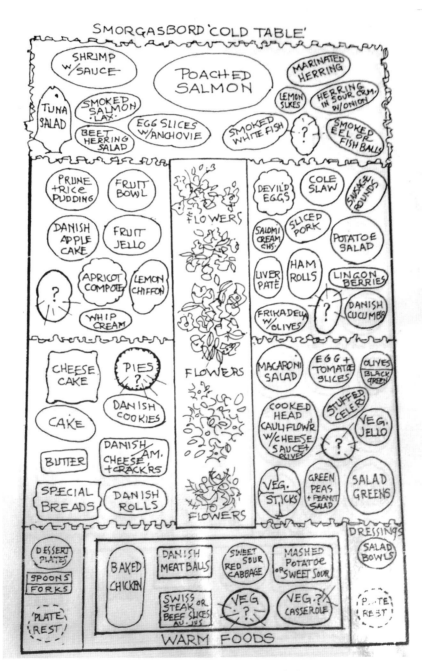

Danish Smorgasbord food layout. *Courtesy Richfield Historical Society.*

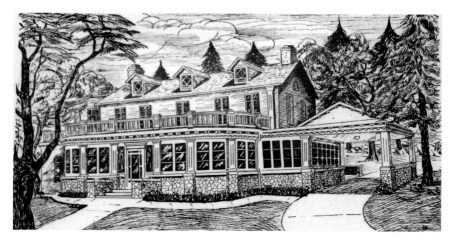

Danish Smorgasbord exterior. *Courtesy Richfield Historical Society.*

what he did if they didn't make those three trips! He didn't allow tobacco or alcohol on his property. He was a wealthy landowner who used the title of "Lord."

He married Emily Oviatt in 1841. She was only eighteen to his forty. He built a house, patterned after an English manor, on more than three thousand acres in 1843. Part of this acreage is now part of Furnace Run Metro Park. The house originally consisted of two parlors downstairs and two bedrooms upstairs. Farnam later added an indoor kitchen and a third bedroom. Everett died in 1884, and his wife died a few months later.

In 1910, the house was purchased by Ella Mayer, who added a curved porch and a stone wall supporting it, as well as a side porch and porte-cochere. It was during this time that the house is rumored to have been a house of ill repute. Of course, gambling was part of the entertainment. The house was bought and sold a few more times before Theodor and Anne Marie Kirk bought it in 1948 and opened the Danish Smorgasbord, with recipes from Denmark. After they retired, their daughter and son-in-law ran the restaurant until 1972. After that, the house went into a decline.

The house is currently a seven-thousand-square-foot, five-bedroom home with the original staircase railing. The old watering trough in the side yard is still there. Everett called it the "Devil's Footprint." A nearby fir tree has one of its trunks bent into an *L* shape, making it possibly an American Indian signal tree.

The house is reportedly haunted. Farnam's fourth child, Emily, died at the age of six when she fell into a cistern and drowned. Some say her ghost is

in the house. There are said to be more than sixty-five ghosts at the manor based on reports of visiting spiritualists and guests who have seen them. Another is Mary Lynn, who was a housekeeper who was jilted by one of the patrons in the 1920s. And there is Timmy, who lived down the road and died at age ten after a horse kicked him in the head.

DODIE'S DINING ROOM/HIGHLAND TAVERN

Dodie's was located at 808 West Market Street. It was founded by Dodie Ridge in 1929. Paintings of flowers hung on the walls, and faded plastic tablecloths covered the tables. Cigarette burns were spotted here and there. Dodie's was known for home cooking and a very laidback atmosphere. Judge James Barbuto bought it in 1981 and sold it in 1986. It closed in 2007 by owner Vaughn Morrison after going through several owners. Morrison was evicted for not paying the rent.

The Highland Tavern is currently in this location. The tavern has more than one hundred different beers, with forty on tap. It also has a large selection of wine and big-screen TVs.

THE EMBERS I AND II/HOUSE OF 7 GABLES/WALT GARNER'S RESTAURANT AT HIGHLAND SQUARE

During World War II, Thomas Garner served in the U.S. Army. After the war, in 1947, he and his brother, Walter, opened Garner Brothers Drive-In Restaurant in Akron. They served the first commercial double hamburger, called the "Tom and Walt" burger, and the first commercial boxed chicken dinner in the United States.

In 1956, they opened the 150-seat Embers Restaurant at 1985 West Market Street in what was the House of 7 Gables, owned by Charlie Malinoff. The House of the 7 Gables was originally built as a residence that became a barbecue sandwich shop. It was a speakeasy during Prohibition, and after 1933, they opened an outdoor beer garden until the city shut them down because the city didn't like food outside.

There was an antique Franklin stove in the bar of the Embers. The dining room walls were covered with pages from a folio of Shakespeare's

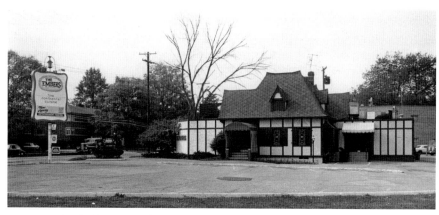

Top: Embers Restaurant, Akron, 1970. *Courtesy Akron–Summit County Public Library;* Akron Beacon Journal *Photo Collection, Summit Memory Project.*

Middle: Garner Brothers Drive-In. *Courtesy Akron–Summit County Public Library; Restaurant Collection.*

Left: Embers Stocks. *Courtesy Akron–Summit County Public Library; Restaurant Collection.*

plays. The stock market reports were posted by curvaceous "broker's clerks" wearing bikini-like costumes—this was called "Stocks and Blondes." The girls would report on the stock market nightly. Word of this got around, and the New York Stock Exchange asked Garner to stop this practice. He said the novelty had worn off and complied. The waitresses looked like Playboy Bunnies. The Embers also had go-go dancers. The West Market location closed in 1970.

The Embers had dishes named after notable people. One was the LBJ, which was a butt burger. They also had live entertainment in the Underground Room.

Walt and Charles Masino, son of infamous Tony Masino, opened the Embers II on "the strip" at 1546 State Road in Cuyahoga Falls in 1968. This restaurant had a Medieval-modern décor with stained-glass windows from Cleveland's old Hollendel Hotel as wall panels. In 1970, it was owned by Masino and George Pappas. It closed in 1972. The restaurant was previously Martini's II.

After the closing of the Embers, Walt Garner took over Highland Square Brown Derby and called it Walt Garner's Restaurant at Highland Square at 834 West Market. Garner also managed the University Club for twenty months after its takeover by the University Alumni Association. Tom Garner opened the Rail at 33 West Streetsboro Street in Hudson in 1970 in two railroad cars and a caboose built in 1934. The place was filled with track lore and served hamburgers and milkshakes. It closed in 1980.

FIORE'S ITALIAN STEAKHOUSE

Fiore's Italian Steakhouse opened in 2013 at 85 West Montrose Avenue in Copley in what was previously home to Nicollini's and Bennigans, on Restaurant Hill. Chef Roger Thomas left the Sheraton in Cuyahoga Falls and joined Fiore's in 2014 to try to get the business going. There was a large outdoor fire pit and a small stage for music. They specialized in veal dishes. Despite bringing in Chef Thomas, the restaurant closed in 2014.

FLEMINGS PRIME STEAKHOUSE AND WINE BAR

Flemings Prime Steakhouse and Wine Bar is located at 400 Medina Road in Copley. It offers USDA prime beef, wet and dry aged. Steaks are broiled at 1,600 degrees or iron-crusted.

Flemings Prime Steakhouse Mint to Be

1 ½ ounces Gentleman Jack
1 ounce ginger liqueur
2 ounces pomegranate juice
½ ounce simple syrup (see note)
8 fresh mint leaves

Pour all ingredients, except mint leaves, into a cocktail shaker filled with ice. Shake well. Strain into barrel glass filled with ice. Garnish with mint leaves. Makes one drink.

Editor's note: You can purchase simple syrup or make your own. To make, combine equal parts granulated sugar and cold water in a saucepan over medium heat. Stir continuously until sugar is completely dissolved. Cool completely. Refrigerate in jar or bottle for up to one week.

Akron Beacon Journal, February 6, 2013, page D2

GASOLINE ALLEY

Gasoline Alley was opened at 870 North Cleveland/Massillon Road in Bath in 1996 by Al Kerkian and Susan Johnson. They opened as a catering operation in the mid-1980s in a converted Marathon station. They serve more than sixty different sandwiches. The interior is full of old license plates, framed racing pictures, memorabilia from movie stars, advertising posters and vintage 1950s bicycles hanging from the ceiling. The deli seats sixty-four.

GRAPPA'S

Bill Owen of Horner's and Chef Scott Jones opened Grappa's in 1999 in the former Horner's in Fairlawn Plaza. The menu included sautéed scampi and veal chops. Owen soon sold his share to his partners to co-manage the Tangier. In 2000, Grappa's closed and reopened as Beau's Grille. Scott Jones became chef at Glenmoore Country Club in Canton.

Grappa's Roasted Garlic and Green Peppercorn Meatloaf

1 head of garlic
2 tablespoons olive oil
half a medium onion, finely chopped
half a rib of celery, finely chopped
half a tomato, finely diced
2 tablespoons chopped parsley
2 tablespoons chopped cilantro
2 tablespoons Dijon mustard
1 tablespoon cracked black pepper
1 ½ tablespoons blanched green peppercorns
2 tablespoons salt
1 tablespoon fresh thyme
3 eggs
½ cup bread crumbs
3½ pounds ground veal and beef

Cut the top off the garlic head, place in garlic roaster or small, covered baking dish, pour olive oil over the top and roast in 350-degree oven for one hour, basting with oil every 20 minutes. Remove from oven and squeeze the bulb from the bottom to remove the roasted garlic cloves.

Combine all ingredients in a large bowl and mix with an electric mixer or by hand. Place the mixture in a loaf pan (two pans if necessary), cover with foil and bake in 400-degree oven for 45 to 50 minutes. Makes six to eight servings.

David Giffles, *Akron Beacon Journal*, January 7, 1999, page 67

GROTTO/PUB BRICCO

The Grotto Restaurant opened at 1841 Merriman Road in 2003 with jazz and blues on Saturday nights in the dining room. Chef Prpich expanded the menu to include rack of lamb, Cajun snapper and duck. In 2009, Pub Bricco, an upscale burger restaurant, opened in this spot.

HOPOCAN GARDENS/DEVORE'S HOPOCAN GARDENS

In 1942, Mike and Katherine Milich and Joe and Mertie Palmer opened Hopocan Gardens at 4396 West Hopocan Avenue in Norton in a building they leased from William and Helen DeVore. William and Helen took over the business in 1945 and retired twenty-four years later. They served Serbian fried chicken with rice and tomato sauce and coleslaw. When they retired, their grandson, Brian Canale, took over managing the restaurant.

In 2001, Hopocan Gardens was accused of employing 138 minors for more hours or later in the evening (until 10:00 p.m.) than the Fair Labor Standards Act permits. Some minors worked in the kitchen, which is also prohibited by law. The restaurant was fined $2,500 for repeat overtime violations. The owners appealed. Hopocan said they wouldn't hire fourteen- and fifteen-year-olds anymore.

Chicken-House Slaw

1 cup white vinegar (5 percent acid if available)
¼ cup vegetable oil
½ cup sugar
Pinch of salt
1 head of cabbage, decored

Put first four ingredients into a bowl and stir until sugar and salt dissolve. Set aside. Shred cabbage finely, using some of the outer leaves to add a bit of green. Pour dressing over slaw. It's ready when it softens. You may want to add more sugar to taste.

Charlene Nevada, *Akron Beacon Journal*, August 20, 1998, page 71

HOUSE OF HUNAN

Dave Kung opened the House of Hunan in Fairlawn Plaza in 1983. The House of Hunan specializes in Hunan and Szechuan Chinese food. The original décor was a cross between Las Vegas glitz and Chinese. Now it is festive with fans and beaded curtains. Booths and chairs are blue. Tables are covered with fitted vinyl. Candles and silk flowers are on every table. Big woven fans decorate walls, and lacquered screens separate the foyer from the dining room.

It has an extensive menu, and in 1999, it added a sushi bar. In 2000, sushi chef Eddy Wang and waiter Joe Ma left to open their own restaurant in Mentor. In 2004, Thai food was available at the House of Hunan in Fairlawn. A new tech bar was installed so that patrons could plug in their tech devises. Also, a granite-topped bar and a wine room were added. White napkins atop black wood tables were added, along with faux light-wood flooring in the main dining room. The oversized Buddha remained at the front door.

In 2000, they opened the House of Hunan at 12 East Exchange Street in a building that was constructed in 1919–20 and was the headquarters of the Akron, Canton, Youngstown Railroad. This location seated eighty. This was the second location for the family-owned restaurant headed by President Jack Suen. The space had wood floors and a black ceiling. In 2015, the downtown location closed. The lease was up, and the building owner didn't want to renew it—or they couldn't agree on terms of the lease. Pad Thai, owned by Timothy and Joann Ly, opened in the space in 2015. Pad Thai serves Thai food and sushi, with the original location at Summit Mall. There are locations in Stow and Hudson also.

House of Hunan Wontons

½ pound ground pork or beef
⅓ cup water
1 tablespoon minced green onion
¼ teaspoon minced fresh ginger
1 ½ tablespoons soy sauce
2 tablespoons minced celery
1 package wonton skins

In a bowl, combine meat and water and mix with fingers. Mix in onion, ginger and soy sauce. Add celery and mix well.

Place wontons on a work surface. Place about a teaspoon of meat mixture in center of each wonton. Moisten edges with water. Fold in half, matching up points. Press to seal. Moisten one point contiguous to the fold. Bend wonton until the moistened point meets the other point contiguous to the fold. Press together. Continue with remaining wrappers and meat mixture.

House of Hunan Wonton Soup

10 cups chicken broth
1 tablespoon soy sauce
½ teaspoon sesame oil
½ pound spinach, cut in shreds
wontons

In a large pan, combine broth, soy sauce and sesame oil. Bring to a gentle boil. Add spinach and boil until limp. Add wontons and boil gently for about 3 to 5 minutes. Serves 6 to 8.

Jane Snow, *Akron Beacon Journal,* June 30, 1995, page 38

HULL'S BARBECUE

The one that started it all. Hull's Barbecue was the first drive-in restaurant in Summit County, located at 1335 Copley Road. It was opened in 1927 by butcher Clinton Hull and his wife, Fairy. The idea of a drive-in restaurant came from Mrs. Hull's relative, who opened one in Detroit. America's love affair with cars led people to enjoy eating in their car.

Akron University students were hired as curb boys, racing between car and kitchen. These were the first carhops in Akron. The drive-in was so popular that by 1930 the Hulls had built an addition and were open twenty-four hours. Dozens of drive-in restaurants followed Hull's into business: Swenson's in 1934, Waterloo Drive-In in 1946, Garner Brothers Drive-In in 1947, Ladd's in 1949, the Sky-Way in 1952 and the Hungry I in 1958, just to name a few.

The Hulls retired in 1947, leaving their daughter and son-in-law, Mr. and Mrs. Clayton Hoffman, to operate it until the building was sold in 1952.

KEN STEWART'S/WESTGATE TAVERN/WESTGATE LOUNGE

Ken Stewart's Grille opened in 1989 in what was Foley's Restaurant and, before that, the Westgate Lounge, which was owned by Gus Moise, who in turn purchased it in 1950 from Thomas Themely, who called it the Westgate Tavern. It was originally owned by Jimmy Nicholas.

Ken Stewart's is located at 1970 West Market Street. The Grille has many wine tasting dinners that are very popular with the clientele. This is a very upscale restaurant that was popular from the beginning and has maintained that popularity. Even Tony Randall has shown up without reservations and had to wait at the bar for a table. The Grille is known for its steak, walleye and French salad dressing. Stewart is known for his flashy eyeglass frames, especially the red ones. Many golfers can be found at Ken Stewart's during Bridgestone's Firestone PGA Open.

Stewart once said that his restaurants produce thirty gallons of grease per day! He introduced Kobe-style beef in 2003. Stewart's family once owned a Brown Derby chain, and that's where he learned the restaurant business.

In 2000, Ken Stewart bought what was Li'l Joe's Pub at 1911 North Cleveland/Massillon Road in Bath and totally remodeled and redecorated it to become Ken Stewart's Lodge. (Li'l Joe's Pub was owned by the Iacominis and was known for lobster and prime rib. It was also known for giant portions and moderate prices. The restaurants were red and black and dimly lit.) The Lodge has a rustic outdoor fireplace and a hand-carved totem pole of frolicking bears. Dining room décor is rustic-chic. The Lodge seats two hundred. Hand-hewn logs were shipped from Montana to create the look of the Adirondacks-style interior. There are moose antler chandeliers, murals of outdoor scenes and white linen tablecloths. The men's room has three stuffed boars' heads hung above the three urinals.

In 2008, Stewart and Parry Girves opened Stewart's Tre Belle Restaurant. Tre Belle means "three beauties," and Stewart has three daughters. This restaurant is on the same site as the Lodge and shares a wall with the Lodge. Tre Belle serves Italian food.

Stewart also had a restaurant in Cleveland for a few years but said he closed it to concentrate on his Akron restaurants.

Ken Stewart's Grouper with Sun-Dried Tomato Crust and Tarragon Butter

2 grouper fillets (10 ounces each), skinned
salt and pepper
½ cup flour
1 egg beaten with 1 tablespoon water
½ cup chopped sun-dried tomatoes packed in olive oil
1 cup fresh bread crumbs
¼ cup extra-virgin olive oil
tarragon butter (recipe follows)

Season fish fillets with salt and pepper and dust lightly with flour on both sides. In a shallow bowl, coat fish with egg mixture.

Process drained sun-dried tomatoes into a paste in food processor. Scrape into a bowl and with hands mix with bread crumbs. Pat crumb mixture onto both sides of fillets.

Sauté fillets in olive oil until evenly browned on both sides but not cooked through. Place on a baking sheet and bake at 400 degrees for five minutes, or until fish is just cooked through.

Spoon tarragon butter onto two dinner plates. Place fish on top of sauce and serve. Serves two.

Tarragon Butter

1 tablespoon cold water
1 stick (8 tablespoons) butter, cut in small cubes
1 tablespoon chopped fresh tarragon

Place water and butter in a small saucepan. Whisk together over high heat until butter is melted and sauce is creamy. Whisk in tarragon.

Ken Stewart's White French Dressing

1 cup Hellman's mayonnaise
¼ cup grated yellow onion
1 teaspoon Dijon mustard
1 tablespoon plus 2 teaspoons distilled white vinegar
1 tablespoon plus 1 teaspoon sugar

Place mayonnaise in a bowl. Grate the onion on the grater disk of a food processor or the large holes of a box grater, then mince finely by hand. Measure onion, packing down. Add to mayonnaise. Add remaining ingredients and stir well. Cover and refrigerate overnight before using. Makes about 1 cup.

Jane Snow, *Akron Beacon Journal*, October 3, 2001, page B5

KINGFISH

Kingfish opened at 115 Montrose West Avenue on Restaurant Hill in Copley in 2016. The restaurant is owned by a team of industry veterans, Hospitality Restaurants, that also manage Rosewood Grill in Hudson. The coastal décor is understated in black, deep blue and gray. There is a sizeable bar. It features fresh, seasonal specialties and a focus on seafood. The building has a twenty-foot metal sailfish on the roof.

LANNINGS/EL MAR

In 1970, Frank Lanning Barnett opened Lannings at 826 North Cleveland/ Massillon Road, in what was the El Mar Restaurant, which was opened in 1960 by Martha Simmons, formerly of the Triangle Restaurant. The building is a vintage Mediterranean style along Yellow Creek. The interior of the El Mar was black and gold. Lannings's bar has the original brick of the El Mar along with the brass horse in the middle of the gorgeous bar. The dining room is long and narrow, and tables are rather close. It has a pianist in the bar on the weekends. The waiters are all male and wear tuxedos. It is very old-style here. The whole concept of Lannings was based on the Colony Restaurant in Pittsburg, Pennsylvania, which Frank visited.

Barnett hired a decorator from Cleveland. He was able to get the chef from the Colony to come to Akron, and he hired a Dutch cruise line manager to manage Lannings. All the original waiters were from the Cleveland Waiters' Union. All the desserts were supplied by the French Pastry Shop at Wallhaven.

El Mar Restaurant, Bath Township, 1969. *Courtesy Akron–Summit County Public Library;* Akron Beacon Journal *Photo Collection, Summit Memory Project.*

Lannings is known for steak and seafood, as well as the special steak sauce it sells. The kitchen was expanded in 1985. There was a very limited menu when it first opened, with only six entrées, but it has gotten a bit larger since then. The menus given to women had no prices printed when they first opened, but that practice has changed too.

Frank was the founder of Barney's Car Washes, which was the first drive-through car wash in our area. He also manufactured auto wash racks. In 1971, J. Jess Cecil invested in Lannings and the Grate, which opened that year. Frank ended up in financial ruins, and Cecil became the sole owner of Lannings in 1972. Jess and his wife, Sue, took over. Currently, their daughter, Chris Darnell, has been president and co-owner with her husband, Jeff, who is the general manager.

LIBERTY STREET BREWING/MISTO 1238

Dave Russo was part owner with Roy O'Neil and Chuck Graybill in Liberty Street Brewing, which opened in 1995 at 1238 Weathervane Lane in Liberty Commons. It specialized in Gulf shrimp pasta and oversized veal chops. The restaurant closed in 2004.

In July 2007, Chef Louis Prpich and partner Christopher Agnew opened Misto 1238 in the location of the former Liberty Street Brewing. Prpich opened Greystone Hall in downtown Akron, the Grotto in Merriman Valley and Edgar's at Good Park in Akron. The menu at Misto 1238 was a combination of American, European and Asian influence. They were going for the classics: bacon-wrapped filet, Champagne and caviar. In November 2007, Chef Prpich left to pursue his catering business, and by April 2008, Misto 1238 had closed.

LOU & HY'S DELI

Lou Kay and his brother-in-law, Hy Potrock, opened Lou & Hy's Deli in 1965 on West Market Street. They were both from Russia. The kosher-style deli attracted stars like Martha Raye, Red Skelton, Milton Berle, Rocky Graziano and Gene Berry. It sold three thousand pounds of corned beef a week and was famous for its potato pancakes, chopped liver platters, cheesecake, pecan rolls and black rye bread, among others. Lou's son, Alan Kay, was the owner when they shut the doors in 1998 to make way for a CVS drugstore.

Lou & Hy's Cheesecake

Crust:
4 cups graham cracker crumbs
10 tablespoons melted butter

Cake:
8 packages (8 ounces each) cream cheese, at room temperature
1 ½ cups plus 2 tablespoons flour
2¾ cups plus 2 tablespoons sugar
½ teaspoon salt

1 pint sour cream
9 eggs
2 half-pint containers whipping cream
½ cup powdered sugar
1 tablespoon vanilla
1 tablespoon lemon juice

cherry, blueberry or pineapple pie filling
whipped cream if desired

For the crust: Stir and toss crumbs with melted butter. Press equal amounts into the bottoms of four 8- or 8½-inch round spring form pans, or a 9½-, 8½- and 7½-inch pan. Set aside.

For the cake: In a 5-quart mixer bowl, beat cream cheese with an electric mixer until fluffy. Slowly beat in flour, then sugar. Add salt and sour cream and beat until smooth, scraping down sides occasionally with a rubber spatula.

Add eggs one at a time, beating on low speed after each addition just until egg is incorporated. Bowl will be very full. Turn off mixer. Scrape bowl and stir with a rubber spatula until batter is uniformly mixed.

In a very large bowl, beat whipping cream until slightly thickened. While beating, slowly add sugar, vanilla and lemon juice until soft peaks form.

Pour one-fourth of the cream cheese mixture into the bowl with the whipped cream and fold until incorporated. Add half of remaining batter and fold again, then fold in remaining batter.

Pour over crusts in spring form pans. Place in a boiling water bath and bake in a preheated, 325-degree oven for about 2½ hours; or place pans directly on oven shelves and bake in a preheated, 350-degree oven until cheesecakes are almost set. To test for doneness, gently shake pans. The cheesecakes should still wiggle slightly. Without the water bath, baking time will be about 40 minutes for a 7½-inch cake, 50 minutes for an 8- to 8½-inch cake, and 60 minutes for a 9½-inch cake.

Cool to room temperature, then refrigerate. Before serving, run a sharp knife between the cake and sides of the pan. Release the clamp, spread the sides and lift the sides off the cake. Top with pie filling and decorate with whipped cream, if desired.

Jane Snow, *Akron Beacon Journal*, October 15, 2003, page E2

LOYAL OAK TAVERN/TAVERN WOOD FIRE BARBECUE/AMATO'S/ WOLF CREEK TAVERN

Located at 3044 Wadsworth Road in Norton, the Tavern was built in about 1840 as a hotel. It was a stagecoach stop with hidden rooms and a secret tunnel that runs between the tavern and the County Store across the street. It was also known as Adam's Place in the 1930s and 1940s, when Adam Pinter was the owner. Contraband alcohol was snuck in, and an illicit speakeasy was in operation in the basement. Beer was cooled in an underground stream in the basement. In the early 1900s, the building was said to be used as a children's infirmary.

The Loyal Oak Tavern served home-cooked food in the 1980s in a run-down interior. The cherry-stained paneling on the walls and ceiling was black with dirt, the carpet was thin and patched and there were seafoam green booths held together with tape. The three-story building was decaying.

In 1987, Milo, Mark and Mike Milkovich bought the Tavern and spent $100,000 rescuing it. The wood paneling was stripped and restored. A Wurlitzer occupied one corner of the dining room. The second story consisted of a banquet room and a conference room. There was an eighteen-foot bar in the basement—probably from the Prohibition days. There was an old telephone booth in the lobby.

In 2005, the name changed to the Tavern Wood Fire Barbecue as Ed Ziss became a co-owner/manager with the Milkoviches. A fireplace was installed along with an outdoor deck, and they served ribs. In 2010, the spot became Amato's Italian Restaurant, owned by Ciro Amato, and in 2014, Shane and Amy Moore bought it, did more remodeling and opened as Wolf Creek Tavern, serving burgers, pasta and steak. They have live music on the weekends.

MAISON MARTEL/WALTZ/BOBBY'S VALLEY BISTRO/LACUCINA/ PUCCI'S/SAFFRON PATCH

Pat Martel established the eighty-six-seat Maison Martel in Akron's Merriman Valley in 1978. Maison Martel was located at 1244 Weathervane Lane in Liberty Commons, housed in a replica of Washington's Valley Forge headquarters and a Federal-style Connecticut homestead. Martel was one of the few who brought authentic French cuisine to Akron. Mr.

Liberty Commons, 1991. *Courtesy Akron–Summit County Public Library;* Akron Beacon Journal *Photo Collection, Summit Memory Project.*

Martel was born in Paris, where he became a lieutenant in the French army before coming to the United States in 1949. He served in the U.S. Army from 1950 to 1952.

Martel moved to Akron in 1972 and became the manager of the former Cascade Club. He was also an artist and supported the arts. Each month, he

allowed a different local artist to display work on the walls of the restaurant. The interior of the restaurant was fashioned after an intimate French country inn. Silk flowers were on every table in the two main dining rooms, which had an eighteenth-century atmosphere.

Martel retired in 1991, when macular degeneration stole most of his eyesight. In 1992, Walt Leary opened Waltz in this spot, and by 1993, Sally and Bob Petrovich had opened Bobby's Valley Bistro in the spot. Bobby's had a Continental menu similar to the Bistro in Green, specializing in veal marsala and white pizza. Then, in 1995, LaCucina opened in this spot, owned by Ricardo Sandoval and Franco Baffice. LaCucina had a contemporary Italian menu and specialized in penne arrabbiata and zuppa di pesce. The restaurant was sold in 1999 to Chef Chris Quinn and Gus Galucci, who opened Pucci's in 2000. Pucci's had a romantic, Tuscan décor. Pucci's closed in 2003 and moved to Cleveland.

George Stamos opened the Saffron Patch in 2004. The restaurant specializes in Indian dishes such as Tandoori-baked Indian flatbreads and mango chicken.

MARTINI'S/UPPER ROOM RESTAURANT

Martini's was opened in 1933 at 1414 Copley Road in West Akron by founder Aquila (Joe) Martin, who previously worked for Joe Gareri. Then William Martin took over. In about 1959, Martini's Wonder Bar added the new Weathervane Room and updated the kitchen.

In 1965, Martini's had two fires. The first fire did $4,500 worth of damage, and the second fire started near an oven and did $2,200 worth of damage to the kitchen equipment, the ceiling and the roof. They opened Martini's II on State Road in the early 1970s, but it closed after only a few years.

The restaurant came back after a devastating fire in 1979 that caused $100,000 worth of damage. Flammable liquid was used to start the fire in three places, and someone tried to open the safe. A seventeen-year-old was responsible for the arson on this fire. The reconstruction of the 150-seat establishment, heavily damaged by fire, took several months.

In 1983, under the ownership of William's brother, Robert Martin, the restaurant was closed because of tax problems. Its signature dish was Martini Noodles, or thick noodles in a creamy, mild cheddar cheese sauce.

In 1994, Reverend Carl Reaves bought the building and called it the Upper Room Restaurant. A fire did $35,000 worth of damage to the roof.

MARY COYLE'S

Mary Coyle's was founded in 1937, with the first store being at 26 East Exchange Street. The 780 West Market Street store in Highland Square was opened in 1937. Three others were added for a total of five: 166 West Market, 206 East Cuyahoga Falls Avenue and 329 Portage Trail. In 1951, four stores were sold, and Mary Coyle's moved out West. The Highland Square store sold to Jack Coutrap in 1963, and he sold it to the Mary Coyle Corporation; it filed for protection under Chapter 11. Then, in 1987, Michael Trecaso purchased the store.

Trecaso calls himself the "Prince of Pasta" and the "Purveyor of Parfaits." He operated Trecaso's Restaurant at 122 South College Street, near Akron University, until 1996. He worked as a soda jerk at Mary Coyle's in the mid-1960s. Trecaso's served Italian food and pizza. Its pizza has won Best Pizza awards several times.

Mary Coyle's is an old-fashioned ice cream parlor and pizza shop. There are vintage toys on the wall. There's a soda fountain and cases brimming with chocolate. It is small and cozy. The display cases, fountain and coolers are all original. Homemade ice cream and the Banana Bowl are the specialties. The Banana Bowl is its version of a banana split, and it sells a lot of them!

Who was Mary Coyle? Born Mary Heggy, she was the sister of Ben Heggy of Canton candy fame. And that is the brand of chocolate sold at Mary Coyle's.

MILICH'S VILLAGE INN/VILLAGE INN CHICKEN

Mirko and Katherine Milich founded Milich's Village Inn at 4444 South Cleveland/Massillon Road in Norton in 1955. Sons Dale and Richard ran the restaurant after 1970. They served Serbian fried chicken, rice with tomato sauce and coleslaw. They served six thousand meals per week in the cafeteria-style dining room.

In 2014, the Miliches threatened to close the spot, but Scott Marble, former ice cream store owner, stepped in to purchase the four-hundred-seat restaurant. The Miliches did not sell the Milich name with the property, so the restaurant is now called Village Inn Chicken.

PARASSON'S

Anthony Parasson started making pizza in the back of Superior Café in Barberton, a bar owned by his mother in the late 1950s. Prior to that, George and Sylvia Parasson, parents of Anthony, opened Parasson's Barbecue Restaurant at 3 Ira Avenue in 1944. It served barbecue ribs, chicken, pork, beef, spaghetti and salad. Anthony opened his first restaurant in Barberton in 1960 and called it Tony-o's Pizza. This location was rebuilt in 1987, and the menu was expanded to include pasta, subs and salad.

Anthony opened his second location in North Hill in 1967 and called it Tony Parasson's Restaurant. Eventually, all locations were renamed Parasson's. In 1974, he opened the third restaurant in the location in the former Stow Smorgasbord, on Darrow Road in Stow. The Waterloo Road, Akron location opened in 1975. Several others have come and gone over the years.

Anthony died in 1982, and his son Tony took over the business at age nineteen. Anthony's other son, Mickey, opened a bar in Merriman Valley in 2012 in the former Nuthouse Bar in Liberty Commons and renovated it. It is called Mickey's and is located at 1310 Weathervane Lane. Mickey added an oak bar. The restaurant has no kitchen, but Mickey is getting food from local establishments to serve as complimentary appetizers during happy hour.

In 2016, the North Hill location closed. When this location opened, North Hill was mainly Italian, but it has had a heavy concentration of Asian refugees recently and business had slowed.

Parasson's is a full-service eatery with a casual atmosphere and is reasonably priced. It is known for its signature creamy Italian salad dressing.

PENINSULA INN/PENINSULA NITE CLUB/WINKING LIZARD

Winking Lizard Tavern/Peninsula Nite Club sign. *Courtesy Winking Lizard Tavern.*

The Peninsula Inn opened in 1850. It closed in the 1980s. It was purchased and reopened in 1986 as Wizard of Za Bar, which offered gourmet pizza. Wayne Lang and Dan Tyler bought the site from Robert Hunker and reopened it as the Peninsula Nite Club in 1987. They first opened the enclosed porch and "peanut gallery" lounge, where peanut shells cover the floor. They served drinks and burgers Monday through Saturday and had live entertainment on weekends. The downstairs area was revamped to a cabaret-style piano bar.

The interior was said to be a mix of carousel, carnival and game room. There were large wooden animal figures, clocks that recorded different time zones and white lights strung along the bar, along with a pool table, pinball machines and a jukebox. There was a maze of wooden dining rooms with red tablecloths, with mirrors and photographs from floor to ceiling. The upstairs ballroom had zebra-print chairs, and a disk jockey played music for dancing on the weekends. The building was only closed for twenty months out of all those years! In 1990, the Peninsula Nite Club closed, and Winking Lizard opened in 1991.

The parking lot for the Winking Lizard is right where the towpath trail begins, so the Lizard is a popular spot just about any time, day or night. The building has housed a bar ever since the Ohio and Erie Canal days. In 1995, Natasha the iguana, the four-foot-long house lizard, died of heart failure. Natasha lived in a cage just inside the door to the bar. Owner Walt Callan got a replacement.

RED PEPPER STEAKHOUSE

The Red Pepper Steakhouse had its beginnings as an athletic club at the corner of Bowery and Bell and moved to Barber Road in Norton in 1960. The restaurant was founded by Katherine and Louie "Bony" Juhasz, who was a sports enthusiast who sponsored baseball teams and boxing matches

and even built a baseball diamond beside the restaurant so that kids had a place to play. He started the restaurant when he returned from the army during World War II. He sponsored many AA baseball teams.

His son, William, ran it after the death of his parents in 1981 and 1994. This was a hangout for the athletic crowd. The restaurant closed in 1999.

ROMANY

Eugene Gruhler was chef and proprietor of the Romany when it opened at 829 West Market Street in Highland Square in 1938. It was only in business for a few years. There was a cocktail bar and Romani music by a famous cymbalist. The restaurant was located across from the Highland Theater. It sold a plate of whole lobster for eighty-five cents in 1939. Gruhler owned the Gruhler Cafeteria in the basement of the Metropolitan Building on South Main Street in 1932 and offered "all you can eat for 37 cents." He was also the manager of one of Akron's outstanding restaurants, the Black Whale, before Prohibition. His daughter, Selma Gruhler, married German schoolteacher Max Moch, who was part owner of the Romany in 1939. It closed shortly after 1940.

SWENSON'S

Swenson's. *Courtesy Akron–Summit County Public Library; Ruth Wright Clinefelter Postcard Collection.*

Swenson's Drive-In started with the opening of Buchtel High School in 1931. There was no student eating facility in the new high school, so Wes Swenson loaded sedans and trucks with sandwiches and pop and sold noon snacks to the students in the driveway of the school.

The South Hawkins location was the first out of seven locations. Wesley Swenson and Guy Witt opened the first one. Then Steve Thompson bought all locations. A new building was built next to the old one on South Hawkins in 2005. It is known for its fleet-footed carhops, mostly Akron University

students. In the 1930s, the carhops wore white linen knickers, black stockings, long-sleeved white shirts and black bow ties. It is known for its sweet hamburgers and, of course, the Galley Boy!

TAVERNE OF RICHFIELD

Located at OH 176 and Route 303, the Taverne of Richfield was built by Ohio canal boat builder Lewis Ellas in 1885. The three-story Victorian building was a hotel and a restaurant. It was once used by Cleveland oil baron John D. Rockefeller as a summer home.

In the early 1920s, during Prohibition, Mike Gyenge owned the property. It was most likely a bordello and speakeasy during Prohibition. In 1938, Gyenge was arrested on liquor selling charges, and in 1939, he was charged with selling high-powered beer without a permit. The defendant claimed he thought his permit allowed him to sell both 3.2 and high-powered beer.

During the 1940s and 1950s, the Taverne was called the West Richfield Inn and served chicken and steak dinners. In the late 1950s, the building

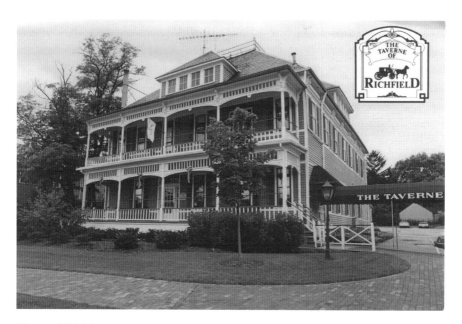

Tavern of Richfield. *Courtesy Akron–Summit County Public Library; Ruth Wright Clinefelter Postcard Collection.*

became a popular eating and drinking establishment known as the Underground, owned by Joseph Smee. The building was condemned due to lack of maintenance.

Mel Rose purchased the Taverne in 1977 and put a lot of money into repairs and remodeling. The Taverne got a lot of customers from the Coliseum, and when it closed in 1994, it really hurt the Taverne's business. Mel Rose closed the restaurant in 1996. In 1998, Dr. Doty purchased the building for use for his dental offices, but that idea fell through and he leased it to the Stancato family, who opened Stancato's Café in 1998 and closed in 2006.

In 2006, Freddie Salem did a lot of remodeling and reopened the Taverne. Serena and Sonya Raybould purchased the Taverne in 2012. They use local, seasonal ingredients and have live music on the weekends. They also have the Underground Martini Lounge.

There have been numerous ghost sightings over the years, with primarily three ghosts. One is the builder of the Taverne, Baxter Wood, who hangs out in the ballroom, which has had the least amount of remodeling done to it. Another is Mrs. Rebbeca Akers, who resides in stairwells and holds peoples' hands when they walk up and down the stairs. And the third ghost is Elijah, son of Rebecca, who opens and closes doors, makes glasses fly off tables, upsets tables and is responsible for chilly drafts.

TERRACE GARDENS

In the late 1940s, Joe Palmer and his wife and Mike Milich and his wife ran Hopocan Gardens. In 1961, the Palmers and Ellen and Roy Johnson opened the Terrace Gardens in 1962 at 288 Hillside Avenue in Norton. It was one of the fried chicken restaurants for which the Barberton area is famous. It served ten thousand chicken dinners per week, with seating for six hundred. It had a side dish of rice, hot peppers and tomatoes. Palmer retired in 1989. The restaurant closed in 1997.

THEMELY'S/MARK II/ROCKNE'S

Themely's was opened in 1960 at 2914 West Market Street by Thomas Themely, who had owned the Buckeye Restaurant on Mill Street and the Westgate Lounge from 1950 to 1958.

Chinese tapestries, two centuries old, adorned walls of Texas ranch wood. Gold lamé draperies, antique furniture and thick, soft carpets welcomed you into the foyer. Waterfall walls divided the foyer from the dining room and intimate cocktail lounge with leopard décor.

There was a three-level dining room divided by sculptures and screens. Cars were parked by attendants, and guests had a wide shelter canopy at the entrance to the restaurant.

Tom Themely had a lot of experience in restaurants. He was a steward at Larchmont Shore & Yacht Club in New York, head waiter at Gallager's Restaurant in New York City, head waiter at Hickory House in Miami Beach and New York and head waiter at Surfside Club of Miami and New York.

Themely's bar. *Courtesy Akron–Summit County Public Library; Restaurant Collection.*

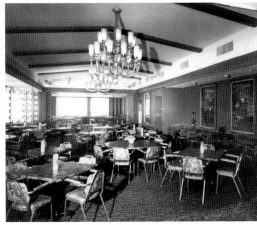

Top: Themely's lobby; *Bottom*: Themely's dining room. *Courtesy Akron–Summit County Public Library; Restaurant Collection.*

Themely's closed in 1968 and was leased to Mark Figeltakis, who renamed it Mark II. This was the beginning of a long list of lessees, and Rockne's ended up purchasing the building.

Rocky Becker founded the Rockne chain of eleven restaurants, with the original one located on Hudson Drive in Cuyahoga Falls, which is now closed. Sandy and Chris Hamad own the oldest chain (since the closing of the Cuyahoga Falls location) at 2914 West Market Street in Fairlawn, in the old Themely's Restaurant.

In 1999, Rockne's sued Larry and Jerry's Grille over stealing trade secrets. Rockne's was known for its Firestone salad and jalapeño peppers

VACCARO'S TRATTORIA

Linda and Frank Vaccaro opened a beverage store in 1956 on South Arlington Road and named it the Plaza Beverage. They started selling pizza with the beverages, and it was a big success. They expanded into a small building across the street and opened as Vaccaro's Restaurant. Several expansions later, the business grew to six locations. They were family-style restaurants. Celebrities like Jerry Lewis, Tony Bennett and Jim Belushi ate at Vaccaro's. Linda's sauce and pizza dough was always a hit, and the site was known for its wedding soup.

In 1996, son Raphael and daughter Mary Angela opened an upscale, hip restaurant, Vaccaro's Trattoria, at 1000 Ghent Road in Bath. They had white tablecloths and servers in butcher aprons. This location was very popular with the younger generation, but they still sold pizza. They served creative takes on Italian classics.

In 2014, Vaccaro's was cited fifty-three times in nine months for various health department infractions. The restaurant had to make a series of repairs to refrigerators to bring food temperatures back to code. Some food was not labeled with the correct date, and there were issues with contamination in food storage areas. There were also issues for building maintenance and nine citations for general building repairs.

Vaccaro's Trattoria Meatballs

1 pound ground veal or chuck
½ pound ground pork
3 eggs
½ teaspoon pepper
pinch of salt
2 cups Pecorino Romano cheese
½ cup chopped fresh parsley
seasoned bread crumbs

Gently mix together veal or chuck and pork. Add eggs, pepper, salt, cheese and parsley and mix lightly but well. Gently work in enough seasoned bread crumbs to make a firm mixture. Roll into meat balls the size of grapes. Place on baking sheets with sides and bake at 350 degrees for 10 to 12 minutes. Meatballs may be cooled, then frozen. Use directly from the freezer.

Vaccaro's Trattoria Wedding Soup

3 quarts chicken stock or broth
½ cup finely chopped carrots
½ cup finely chopped celery
½ cup finely chopped onions
2 cups finely chopped endive or escarole
2 cups finely chopped fresh spinach
2 cups tiny meatballs
2 cups grated Pecorino Romano cheese
4 eggs
1 cup of Acini di Pepe pasta, cooked al dente
freshly ground black pepper to taste

Measure all ingredients and place them in bowls on the counter in the order they will be used.

Bring broth to a simmer in a large soup pot. Add carrots, celery, onions, endive and spinach. Add the meatballs. Simmer uncovered for about 30 minutes, until carrots are tender.

In a medium bowl, combine cheese and egg and mix well. Scrape mixture in a lump into the center of the simmering soup. Let simmer for 2 to 3 minutes without stirring. Lift the mass occasionally with a slotted spoon to keep it from sticking to the bottom of the pan. The soup is done when the egg-cheese mixture looks firm. Gently break apart with a spoon.

Remove soup from heat. Stir in the pasta. Season to taste with freshly ground pepper. Serve hot. Makes 10 to 12 servings.

Jane Snow, *Akron Beacon Journal*, March 21, 2001, page D5

WEST POINT MARKET BESIDE THE POINT CAFÉ AND MRS. TICKLEMORE'S TEA ROOM

In 2001, West Point Market moved the café to a remodeled space with windows overlooking West Market Street. The new café had seating for sixty-five. There was blond-wood furniture and a floor of burgundy clay tile.

There was also an expanded menu. When the new café was finished, they began construction on the tearoom.

Mrs. Ticklemore's Tea Room opened in 2002. The room had wood beam ceilings and a traditional British tearoom décor, with butter-colored walls stenciled with quotes about tea. The tearoom offered morning, afternoon and high teas.

WHITE HOUSE CHICKEN

White House Chicken was opened in 1942 at 180 Wooster Road North in Barberton by the Pavkon's family. They sold the restaurant in 1990 to the Devore family of Hopocan Gardens. In 2002, Hopocan Gardens opened Hoppy/White House Chicken in Cuyahoga Falls and then started franchising, with nine locations planned.

THE WINE MERCHANT/SIXTEEN EIGHTY/THE MERCHANT TAVERN

Another Merriman Valley restaurant was the Wine Merchant, opened by Lucia Piscazzi and her son, John Piscazzi, in 1971 at 1824 Merriman Road. The restaurant sat sixty-eight and was known for its wonderful food. John Piscazzi was lovingly known as "the Merch." Roger Thomas was chef for many years before opening Piatto in downtown Akron and then moving to Piatto Novo in the Sheraton in Cuyahoga Falls. The Wine Merchant closed in 1996. Dave Russo was chef here before opening up Russo's Restaurant.

Wine Merchant Caesar Salad

2 ounces anchovies, thoroughly drained
½ cup extra virgin olive oil
2 garlic cloves, minced
¼ teaspoon kosher salt
½ teaspoon Worcestershire sauce
4 drops Tabasco sauce
¼ cup fresh lemon juice
2 tablespoons high-quality red wine vinegar

2 tablespoons Dijon mustard
2 egg yolks (see note)
freshly ground black pepper (several grinds)
½ cup canola oil
½ cup grated Parmigiano-Reggiano cheese, plus more for sprinkling on top
2 large heads romaine lettuce, trimmed, washed and dried
2 cups croutons (recipe follows)

Cover the drained anchovies with the extra virgin olive oil and allow to rest at room temperature for 1 hour, until the anchovies plump up. Place the anchovies and the olive oil into a large, preferably wooden, salad bowl with the garlic and salt. Use a dinner fork to mash the anchovies, garlic and salt into a semi-smooth paste. Add the Worcestershire, Tabasco, lemon juice, vinegar and mustard to the bowl and mix thoroughly with the fork. Add the egg yolks and mix well. Season with the black pepper and then whisk in the canola oil. Whisk in the grated Parmigiano-Reggiano cheese.

Make sure the romaine is very clean and dry. Tear it, don't cut it, into bite-sized pieces. Mix the romaine and the croutons into the dressing, gently tossing and mixing until the leaves are completely coated with the dressing.

Serve at once, grating more Parmigiano-Reggiano on top of each salad at the table. Makes 6 to 8 generous servings.

Editor's note: Raw egg yolks carry the risk of salmonella poisoning. We recommend using yolks from pasteurized eggs for this recipe.

Chef Roger Thomas

Croutons

2 cups torn Italian bread
extra virgin olive oil
salt and pepper

Place bread on a large baking sheet, drizzle with olive oil and season with salt and pepper. Bake in an oven heated to 450 degrees for 10 minutes or until toasted and crisp, turning as necessary to keep from burning. Cool before tossing in salad. Makes 2 cups.

Lisa Abraham, *Akron Beacon Journal*, September 11, 2013, page D2

In 1996, Chef Roger Thomas left Ken Stewart's Restaurant and bought the Wine Merchant on Merriman Road with partner Chris Studer. They redecorated, making the restaurant warm and inviting, with cushy booths and white linen tablecloths. Toulouse-Lautrec prints hung on the walls. They had more than two thousand bottles of wine. The menu had stewed duck with olives and pork with bourbon sauce. Sixteen Eighty closed in 1998.

Anthony Piscazzi, great-nephew of John Piscazzi, who owned the original Wine Merchant, opened the Merchant Tavern in 2013, with a nod to his great-uncle. This is a gastropub serving sandwiches, burgers, soup, mussels, pork chops and more. Anthony wanted to create an environment that was comfortable with quality options on the menu so that it would be a place where you would feel comfortable to hang out, while at the same time it is nice enough for special occasions. In the first few years of opening, it has won Best Chef (Victor Todaro) three years in a row, along with Best Bartender two years in a row and Best Bar and Best Patio Dining.

YANKO'S

After losing a confectionery that he had since 1918 at 1274 East Market Street, Nick Yanko began his restaurant career in 1926 at the Buchteleat, a hamburger eatery, by Akron University, before Gardner Student Center was built.

Yanko opened the fifty-seat Bubble Bar Café at 846 West Market in Highland Square in 1940 after buying the Oregon Restaurant that was in that location. There was a Champagne dining room and belly dancers. On

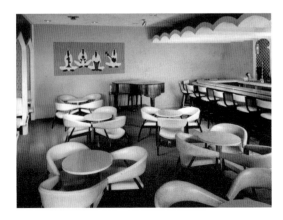

Yanko's Bar. *Courtesy Akron–Summit County Public Library; Restaurant Collection.*

Yanko's Bubble Bar. *Courtesy Akron–Summit County Public Library; Restaurant Collection.*

March 29, 1951, the café suffered a fire, with flames shooting up from the floor. Damages from the fire were $75,000. Thirty-five customers fled the café. The restaurant grew into a four-hundred-seat plush restaurant after that fire. There was a $200,000 expansion in 1958.

Flaming shish kebabs and shrimp Vesuvious were served at the table over a brazier. There was also a large maître d' outfitted in a turban and Arabian garb, named "Rajah," who would visit each table and bow as the entrée was served.

Another fire on December 4, 1969, closed the doors forever. There was $500,000 worth of damage to the contents. The cleaning lady saw a fire in a booth in the dining room. The Brown Derby was right next door and bought the shell that was Yanko's in 1973 to expand its restaurant into a Brown Derby Luv Pub.

After the 1969 fire, Yanko bought a restaurant in Fairlawn Plaza and opened a family-style restaurant, where his famous Beachcomber sandwiches were served.

Yanko's Rice Pilaf

For each cup of uncooked converted or basmati rice:
1 medium onion, chopped
4 cloves garlic, minced

2 tablespoons olive oil
2 stalks celery, chopped
2 chicken bouillon cubes
1 stick butter
½ teaspoon red pepper flakes
2 cups water

Heat oil in medium saucepan over medium heat. Add onion, celery and garlic. Sauté until tender; add bouillon cubes, butter and pepper flakes. Stir until butter is melted. Add water and bring mixture to a boil. Add one cup of converted or basmati rice and stir for 1 minute. Cover pan with lid and reduce heat to simmer. Cook until most of the liquid is absorbed (about 20 minutes). Stir once, remove from heat and replace lid. Leave covered for 5 minutes and stir well before serving.

Debby Stock Kiefer, *Akron Beacon Journal*, May 26, 2004, page E2

Supper Clubs

B efore Prohibition, Akron had lots of old-time saloons, where the men went downstairs and the ladies were upstairs. During Prohibition, there were speakeasies in old mansions or "clubs." This was the beginning of the supper club, where there would be an orchestra for dancing and floor shows and some gambling in the back room. After Prohibition, the clubs were forced to clean up their act and were more about a floor show or dancing and supper.

The Volstead Act created an environment where gangsters, the wealthy and lower classes could all drink and socialize together. Many movie stars started their careers singing and dancing in speakeasies. The poorest-quality speakeasies were called "clip joints" and were notorious for violence. "Blind dogs" and "blind tigers" were also phrases used to describe low-class establishments. Lower-class joints sold "cut liquors." Jamaica gin was the most popular and was called "jake."

I wondered how speakeasies got their name and found this from an 1889 New York paper: "Unlicensed saloon, from speak + easy; so called from the practice of speaking quietly about such a place in public, or when inside it, so as not to alert the police and neighbors."

Let's begin with the most notorious club in Summit County: Semler's Tavern. Akron industrialist Clyde Semler opened the fifty-room hotel and tavern on State Road in Cuyahoga Falls in 1929. It was a rip-roaring resort and a clattering whirl of gambling, booze and jazz in the 1930s.

Semler's Tavern, 1936. *Courtesy Akron–Summit County Public Library; Akron Beacon Journal Photo Collection, Summit Memory Project.*

In 1930, manager Jean Lehman hired orchestras to perform six nights a week in the ballroom. Public dancing was illegal on Sundays in Cuyahoga Falls. An ordinance required musicians to stop playing at 11:30 p.m. on Saturdays. Cuyahoga Falls police officers paid a surprise visit to Semler's at 12:50 a.m. and found "heathens swaying on the Sabbath." Lehman was arrested.

To avoid future trouble, the tavern became a private nightclub in 1932. Tony Masino opened the Castle Club in Semler's Tavern, which was a swanky casino that packed in crowds.

Before we go any further, let me give you some background on Tony Masino. He was known as the "Sweet Prince" of corruption in Akron, founding a dynasty based on horse betting, race wires and plush gambling casinos, all while living above his family's candy and ice cream shop on Mill Street, where he established a bookie joint in the late 1920s. Tony was born in 1890 in Ohio to Antonio and Filomena Masino. His father, Antonio, was born in Naples, Italy, and was a harpist who had organized the Royal Italian

Orchestra before marrying and moving to Akron. Filomena played the violin, and the two of them played at the wedding of Thomas Alva Edison and Mina Miller in Akron. Antonio owned the first confectionery shop in Akron, which he opened in 1883 at Main and Mill where Federman's was. He moved to 49 East Mill in 1893 and in 1903 bought 47 East Mill next to the Colonial Theater; he used the two upper floors as his residence and the lower floor to sell fruit and candy. He was also a pioneer wholesaler and manufacturer of ice cream. After his death in 1916, Filomena and their children operated the confectionery until they sold the building to Kaase's. The Masinos were the first immigrant Italian family in Akron, coming soon after the Civil War.

Tony was in World War I in France and Germany and was discharged in 1919. In 1924, he applied for a passport to travel to the British Isles, France, Germany, Switzerland, Italy and Spain. As early as 1926, the *Beacon Journal* reported that Masino was sued by a Kenmore woman to recover $5,850 in damages and money that her husband gambled away at a restaurant Masino owned in Kenmore. In 1927, he was sued by a man who lost $1,095 in games of chance at Masino's Little York Club near Northfield, near the Crescent Country Club. Little York was a community near Brandywine Falls that had a distillery that was built in 1915 and made thirty barrels of whiskey per day. The Little York Club was the Monte Carlo for Cleveland and Akron gamblers. In 1929, it moved to a building on Guy Buel's land in West Richfield and was called the Broadview Club. The Crescent Club was one of the greatest racetrack betting establishments in the country, run by Clevelanders William Swartz and Ben Levine. It was housed in an icehouse on State Road.

In 1928, police discharged tear gas in downtown Akron gambling establishments. Bookie operators talked about purchasing gas masks. Masino's place on East Mill was raided, but he said he didn't own the place. In 1930, raids on bookie establishments delivered an ultimatum to Masino, head of the race bet business on East Mill Street. He was ordered to close up shop. He and four telegraph operators, as well as two other men, were relaying information over telephones. Masino, reputed head of the Akron bookmaking industry, controlled all local wires and supplied results to various resorts.

In 1930, Masino was mentioned in the investigation of Dominic Maglione, who was born in Italy in 1895 and died in Massillon State Hospital in 1960. He was a resident of Massillon State from 1920 until his death. In November 1930, while he was in the Cuyahoga County Jail, being held

as a federal prisoner awaiting deportation, he signed an affidavit charging that he paid protection money to seven policemen in Akron to permit him to operate an underworld resort. He told immigration inspectors that he didn't want to be released from jail while awaiting deportation for fear he would be slain by enemies.

In 1932, the Akron Vice Squad visited the headquarters of Tony Masino at 47½ East Mill Street, where they found telegraph wires bringing race results or sporting events, operating for twelve years in the city. Masino's place on East Mill was called the Portage News Bureau. Tony's brother, Rocco, was his manager, and longtime school chum, Ed Shippacasse, kept the records. This is the year that Tony moved into Semler's Tavern in Cuyahoga Falls and opened the Castle Club, where he had his race wire headquarters.

Prohibition was still the law, but alcohol flowed freely. Gambling was illegal. In 1933, Cuyahoga Falls police arrived at the Castle Club with sledgehammers and smashed the door down while Masino was inside smashing booze bottles. Officers seized gaming equipment and a few whiskey jugs that Masino missed. Masino was charged with illegal possession of liquor and possession of gambling devices. His defense was that he wasn't

Semler's Tavern Bar. *Courtesy Cuyahoga Falls Historical Society.*

the owner but just worked there for a modest wage. Yet his name was on the lease! Over the next few years, the tavern was raided more times than a cookie jar. In 1936, police officers lobbed tear gas into the club, and a crowd of three hundred scrambled out. Masino eventually left and opened up the Merry Go Round in Akron, and Semler's was managed by the Walbridge Club from 1936 to 1938. The Merry Go Round was located at 45 South Main Street, near the Palace Theater, and was said to be the best club between New York and Chicago. The club had elaborate floor shows, orchestras and dancing. It also had a round bar that rotated around the bartender—thus the name. Visiting celebrities would perform at the club when they were in town. The country club set came to the Merry Go Round. About this time, Semler brought back Masino to run the keno operation.

In 1936, Tony Masino was offered a $10,000 settlement on his back income tax suit. He was being sued by the U.S. government for $1 million in back income taxes from 1920 to 1932. The Merry Go Round was raided, as was Shippacasse's place. Masino failed to appear as witness in the trial of Tony Lafatch, who was convicted of highway robbery in the holdup in March at the Walbridge Gambling Casino in Semler's Tavern. Masino was

Tony Masino's trial. *Courtesy Cuyahoga Falls Historical Society.*

accused of hiring the gang of mobsters to wreck the Walbridge Club. The Walbridge Club moved out of Semler's into the Orchard Park Dance Hall at the corner of Route 8 and Route 303, and it closed in 1939.

In 1942, the U.S. Army commandeered the hotel to serve as a training center for World War II. In 1948, Semler sold the hotel to William Smith, and after a remodel, it was renamed the Chesterfield Inn, with a fifty-six-room addition in 1959. In 1963, Gus Girves signed a lease and refurbished the hotel as the Brown Derby Inn. That lease expired in 1977, and Smith's family renamed the hotel the State Road Inn. In 1999, the building was sold and a CVS drugstore was built.

The Merry Go Round was for sale in 1940 and was turned into the Continental Grove Club for a few years before being opened in 1946 as the Latin Quarter Club, minus the Merry Go Round bar, by owners Jack Green, Lew Platt and Mike Adella. In 1943, at 10:00 p.m. on a Friday night, waiters and bartenders went on strike, protesting a wage negotiation deadlock. In 1945, the War Mobilization Act ordered the closing of all entertainment places at midnight. In 1949, there was a sheriff's sale at the Latin Quarter.

DOWNTOWN

Other downtown clubs included the Lido at 34 North Main Street, which operated from 1934 to 1936 in what was the Ritz Club, which opened, briefly, in 1934. The manager of the Lido was fined for permitting dancing after midnight. Hollywood Gardens opened in 1934 at 22 North Howard Street, and in 1936, Philip Azar, the owner, was charged with staying open after hours and violating the Sunday ordinance. The Lido had "lookout men" who would stand outside and watch for police. When they saw an officer, they would notify someone inside to turn off the music. Playhouse Gardens was located at 48 West Market Street, opening around 1934. In 1949, owner Tom Lombardo was charged with disorderly operation, and the liquor board condemned the place and ordered it closed. The board said the club was frequented by "the lowest gutter trash that can be found" and had filthy shows.

The Yankee Inn opened in 1944 and was located at 231 West Exchange Street. It was a swanky club that seated 155 and was owned by George Zennallis (aka George Senior). It was famous for live entertainment like the Four Freshmen, Four Lads, Johnny Ray, Steve Lawrence and Eydie Gorme.

In 1956, George Senior left the Yankee Inn to work as the new manager for Ed George at Tangier. The new manager for the Yankee Inn was Debbie Toth, one of the dancing sisters from Barberton. The owner was Dr. Norm Nolan. The name was changed to Debbie's Yankee Inn.

The Inn was also famous for Divena, the mermaid stripper in a six-hundred-gallon tank. "Aqua-tease" was popular during the 1940s and 1950s. Divena would get into the tank wearing a flimsy gown and swim around, taking off each piece of clothing down to thin panties and a net bra.

In 1957, the Internal Revenue Service seized fixtures from the Inn in a step to collect $2,795.84 in back employee's withholding taxes. The Inn was padlocked.

Club Hollywood was located at 655 North Main Street in what was a former automobile showroom. It had floor shows every weekend, and acts like local Phil Palumbo played there often. Eddie Salem owned the club for several years in the 1950s. It became a Moose Club in 1957 and R.M. Paddison Restaurant Supply in 1973. Bandleader Phil Palumbo opened Palumbo's Nightclub, located at 2555 State Road in Cuyahoga Falls, in 1973. This was the former Red Carpet Restaurant, owned by Pete Kotzambasis originally and then Mark Riley in 1971. Palumbo was a headliner at area clubs for twenty-five years before opening his own restaurant. It was a Vegas-style nightclub. It closed in the mid-1980s.

Nino's Restaurant and Club was located at 451 North Main Street in North Akron, just over the Cuyahoga Falls line. It was owned by Anthony Bologna and Raymond Arnone. They had entertainment on the weekends, and it was a place for singles to hang out during the 1960s. Mamma Llama's & Company was opened at 1110 Brittian Road in 1975 by Tommy Bruno Jr. The dance floor pulsated to the beat of the music. In 1976, Chubby Checker played here. In 1977, Bruno sold the club to Alex Kallas and Dennis Baughman, who opened Mystical Tour. Bruno moved to Singer Island, Florida.

Salem's was opened in 1958 by owner Massoud Salem at 1458 East Market Street. When Massoud retired, sons Paul and Eddie took over. It was known as the House of the Flaming Sword. When it first opened, Pat Pace played there nightly. It always had entertainment. In 1970, its liquor license was suspended for improper conduct—go-go dancers wearing pasties. In 1972, its liquor license was suspended for lewd activities, nudity and profane or obscene language.

The El Cid Lounge was located at 1254 East Tallmadge Avenue. It had floor shows and disco music from 1969 to 1982.

HIGHLAND SQUARE

One long-running club is Annabell's at 782 West Market Street in Highland Square. The club was named for founder Ann Pfleuger and has gone through many owners since opening. Annabell's was once One-Eyed Jack's, owned by Jack Cavalier. Annabell's is the place to go for local and regional punk and heavy metal bands. The bar is on the street level, and downstairs in the basement is where the music is. Shows are usually free.

Freddie Salem bought Annabell's from Ann Pfleuger in 1991. Salem then took over the building that is now Aladdin's in 1992 and opened King Cantina, a gourmet Tex-Mex restaurant. Salem sold Annabell's in 1977 to Anthony Polito, and Polito sold it to the current owner, Billy Reynolds.

PORTAGE LAKES

Portage Lakes has always been known as a party place and has a long history of clubs, beginning with Dietz Landing and Boat House. The Landing was originally the creation of Gottlieb Dietz. In the early 1920s, he razed some old summer cottages and built a dance hall. He had an old streetcar diner nearby. "Scroggy," as he was called, sold the Landing to J.R. MacGregor in 1944. The club was rebuilt and was a popular place to go.

Dietz was located at 401 Turkeyfoot Lake Road and was destroyed by a $100,000 fire in 1956. The blaze was set by an out-of-control car that crashed into the building. The basement was filled with boats. Wires were torn loose from the car, and sparks set gasoline from the car ablaze. There were oil drums in the basement for heating oil, and when they ignited, the whole building exploded.

The White House Restaurant was built in 1820 by George Rex at 357 West Turkeyfoot Lake Road as a stagecoach inn. In 1840 it was purchased by John Thornton and became a residence before it passed on to his son, Samuel, upon his death. It was originally built in the shape of an L. In 1871, Sam tore down one wing. In 1925, it was still owned by the Thornton family and became the White House Tavern. It is now known as the Upper Deck.

The Grandview Inn, at 207 Portage Lakes Drive, opened in 1927 and continued on into the 1960s with many different owners. In 1935, the Inn was raided, and slot machines were found. The owner, Leo Williams, said that a "stranger left them there to keep them from the rain." However, there

had been a long drought. In 1930, owner Frank Meier was charged with liquor possession. The Inn served steak, chicken and shrimp.

The Lakeview Inn was located at 3134 South Main Street, on the corner of South Main Street and Portage Lakes Drive, and was known for bootlegging and gambling during the Prohibition. Giuseppe Murgida, known as "Papa Joe," was the owner. The Inn seated 165 and was in the location formerly known as the first Bertsch's Inn, which burned down in 1919. Other than bootleg booze, it also served chicken, steak, frog legs and ham. In 1927, the Lakeview Inn was raided, and police found twenty-three quarts of bootleg Kentucky whiskey in the ceiling. In 1935, Tony Masino was running the Lakeview Inn. In 1937, a sheriff's raid scattered a crowd of gamblers and seized an $800 roulette wheel, cards, chips and $200 cash. Peter and Joe Kinne were arrested on charges of operating a gambling device. Again in 1937, a police raid took another roulette wheel.

In 1939, the Inn incorporated as a private "nonprofit" club. It had no liquor license and was closed because the state refused to renew its license. In 1943, the bartender was arrested for selling liquor without a license. The

Lakeview Inn. *Courtesy Akron–Summit County Public Library;* Akron Beacon Journal *Photo Collection, Summit Memory Project.*

Inn was raided in 1944, and owner Bill Guiles was arrested on charges of selling liquor without a license. Police found a quantity of liquor that did not bear the State of Ohio tax stamp. The spot served chicken, steak and fish dinners. This location has had many names since the Lakeview Inn. In 1947, it was the Security Veterans' Club, and in 1956, it was the Old Hickory and had $3,000 worth of fire damage. In 1957, it was Chiefs, and in 1959, it was the Roseview Inn.

The Olde Harbor Inn opened during the 1850s on the West Reservoir of Portage Lakes at 562 Portage Lakes Drive. It had great waterside seating and an outside deck for boaters overlooking part of the West Reservoir. The Inn burned down in 1974, and a new spot with its own dock was rebuilt. The Harbor was a place for swingers. The lower level was the Boom Boom Room, which was a dance floor covered in sand. The Inn closed in 2012. It is currently On Tap at the Harbor, a popular waterfront hangout with misting palm trees to keep customers cool outside and music on the deck every weekend. The deck seats 135 and the bar 40. There is a tall decorative lighthouse outside.

Offie Mallo opened Mallo's Bar in the 1940s and operated Mallo's in several locations until he retired in 1977. In 1949, at the 2477 South Main Street Extension location, he received a sixty-day liquor license suspension for Sunday and after-hours sales. Other locations were on U.S. 224 and at 1655 South Hawkins.

Located at 773 Portage Lakes Drive, Crook's Hotel opened in 1904 and closed in 1920. After that, it became Oakland Country Club for a few years before Riley Jerrel turned Riley's Tavern into a landmark gambling joint. His first violation came in 1932. In 1939, Jerrel finished off a porch adjoining the bar and called it the Rumpus Room. The Rumpus Room was also called the Portage Lakes Athletic Club. Riley's was about the only place local to play slots, as nickel and dime slots had been removed from most places. It was very hard to get into; you had to know someone— the old "Charlie sent me." In 1947, the place was raided and stripped of gambling equipment, including slots, craps tables and other devices. This was also the scene of a gangland-style holdup where six men lined up all of the patrons in the casino and took all their cash and valuables.

The name changed to Duffy's at some point around this period. In 1946, officers raided the Tavern and took seven slots, two roulette wheels, two dice tables and a blackjack game. Also in 1946, Riley Jerrel, with a batch of lawsuits against him, headed south to Florida. He sold Riley's Tavern to Sam and Mitchell Braum, who said they were doing away with the Rumpus

Duffy's Tavern, Portage Lakes, 1947. *Courtesy Akron–Summit County Public Library;* Akron Beacon Journal *Photo Collection, Summit Memory Project.*

Room and were going to convert it to a dance hall. Jerrel faced $64,658 in lawsuits. The site were raided again in 1947, and officers confiscated fifty or so bottles of whisky. They had no liquor license. In 1948, the bartender was arrested for bootlegging. In 1954, the Tavern was operating under the name of Lindy's, and it had moved the casino upstairs, with access through a hidden staircase. An explosion that year burned the place to the ground, with $65,000 damages and only $6,000 worth of insurance.

Arnie "Red" Shapiro was working in his family's grocery when the building burned down in 1957. He needed a way to make money, so he started running Shorty's Bar at 1027 East Waterloo Road. He renamed the bar Red's Place and then renamed it Red's. At first, it was a little honky-tonk, a rough place. The jukebox was "always busted in." Red expanded the bar in 1960, 1963 and 1972. On February 11, 1974, a fire destroyed Red's to the tune of $300,000. He rebuilt. The place originally seated seventy-five, and Red expanded it to six hundred. There was live music every night, with local and national acts. It was a place for singles to mingle and dance. Local entertainer Larry Altop was a fixture, as was the band LaFlavour. Brenda Lee sang there, and many other stars, like Tom Hanks, would show up when they were in town. Red's closed in 1988, and Red became general manager of Rosemont Country Club. Then he managed Bucks in the basement of Quaker Square and then the Vault and Crocker's

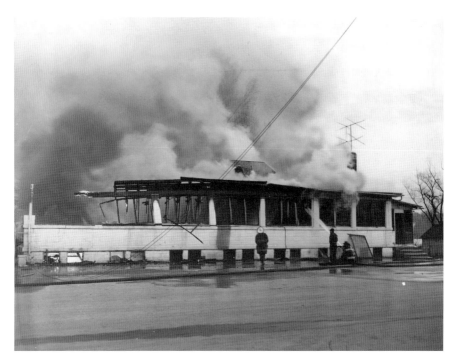

Lindy's Night Club fire, 1939. *Courtesy Akron–Summit County Public Library;* Akron Beacon Journal *Photo Collection, Summit Memory Project.*

at Good Park. He did a short stint as "executive host" at Posh Nightclub when it first opened.

Hook, Line and Drinkers opened in 2006 in an Art Deco building at 530 Portage Lakes Drive. In 2013, Nicoletti's at Park Place opened in that space, and it was closed by 2016, when the building was purchased by brothers Tom, Bob and Herb Hutchison. The building has a large outside patio.

Bibliography

Akron & Vicinity Phone Book, 1950, 1960, 1970, 1980 and 1990. Ohio Bell Telephone Company.

Akron–Summit County Public Library. "Historic City Directories." http://akronlibrary.org/locations/main-library/special-collections/genealogy/historic-city-directories.

———. Special Collections, Local History Database. http://db.akronlibrary.org/DBS/SpecColldbO/Default.aspx.

———. Summit Memory. summitmemory.org.

Akron Topics 8. "Mayflower Hotel, Puritan Room" (May 1931): 37.

Artwork of Ohio. N.p.: Gravure Illustration Company, 1930, part 2, leaf 6.

Newspapers.com. *Akron Beacon Journal*, 1892–2017.

———. *Akron Daily Democrat*, 1892–1902.

———. *Summit County Beacon*, 1839–1910.

Waterhouse, Helen S. "Shopping Here and There." *Akron Topics* 6 (April 1929): 37.

Index

About the Author

Ohio native Sharon Moreland Myers graduated from Cuyahoga Falls High School and the University of Akron with a BS in comprehensive business education. Later in life, she became interested in local history and did programs on various topics of local interest throughout Summit County for years. In 2015, she collaborated with Judy James, Special Collections division manager of the Akron–Summit County Public Library, on an exhibit called "The Golden Age of Restaurants in Summit County." The exhibit was extremely popular, and many programs on the topic were given. Myers has been married for forty-nine years to her high school beau, and they recently moved from Summit County, Ohio, to Naples, Florida.

.